C000178375

THE
Old Photographs
SERIES

OLD HARBORNE

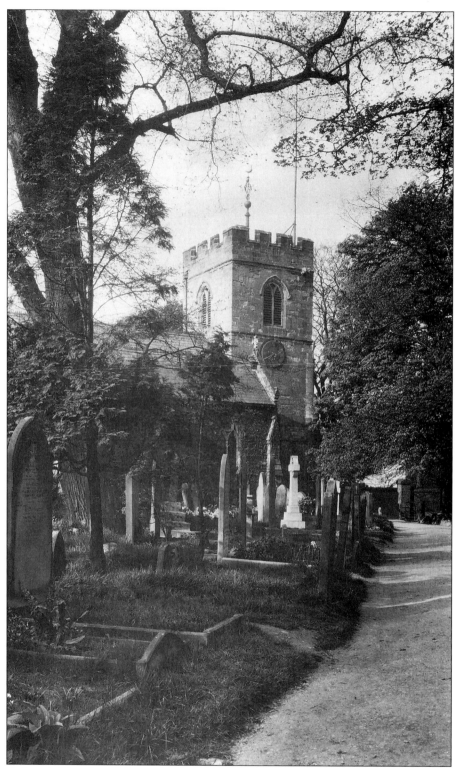

St Peter's Church, 1930's.

THE
Old Photographs
SERIES

OLD HARBORNE

Compiled by
Roy Clarke

ALAN
SUTTON

BATH • AUGUSTA • RENNES

First published 1994
Copyright © Roy Clarke, 1994

Alan Sutton Limited
12 Riverside Court
Bath BA2 3DZ

ISBN 0 7524 0054 1

Typesetting and origination by
Alan Sutton Limited
Printed in Great Britain by
Redwood Books, Trowbridge

Contents

HARBORNE VILLAGE 1834

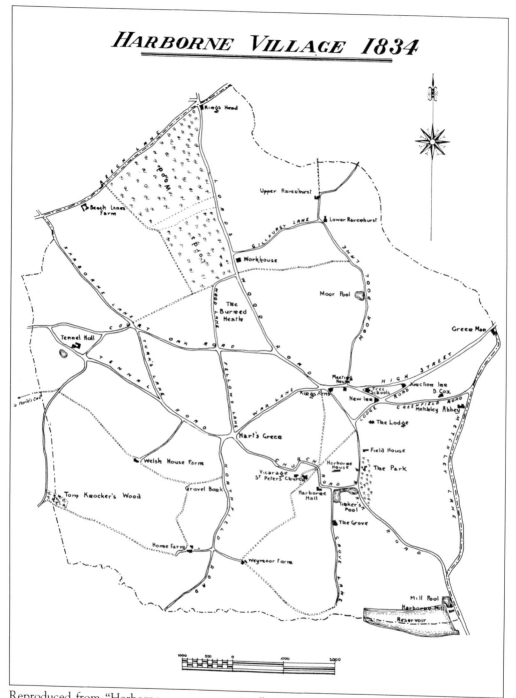

Reproduced from "Harborne once upon a time" written by Tom Presterne and published in 1913. The Map shows the historic boundary of the manor of Harborne.

Introduction

The earliest known mention of Harborne appeared in the Domesday Book of 1086. For much of its early history the Manor of Harborne was church property. At the dissolution of the monasteries it was surrendered to Henry VIII by Halesowen Abbey (1538) and later that year was granted to Sir John Dudley whose family remained in possession of the Manor until 1618 when they were forced to sell it owing to the improvidence of the then Earl of Dudley.

Thus, although Harborne is a place of some antiquity, it should be remembered that until the Victorian period it was a small, unimportant country village in a remote part of Staffordshire.

The Victorian period was a time of steady, if unspectacular, growth for Harborne reflecting its close proximity to Birmingham and to Smethwick (which was originally part of Harborne Parish) and their rapid industrial expansion. Early growth was initially to the south of the High Street but the opening of the Harborne Railway in 1874 encouraged development to the north. As the population increased (from 1,637 in 1841, to 10,113 in 1901) so did the need for services, facilities and organisations. In 1864 the Harborne Local Board of Health was set up and was in many ways the start of modern local government in Harborne. A School Board followed in 1873 (the first 'board school' was in what is now the Clock Tower Centre). By the end of the nineteenth century the face of Harborne had changed for ever; from a small rural village to a bustling Victorian suburb.

Birmingham was also growing rapidly. In 1888 a plan was drawn up by the Corporation to extend its boundaries; the Greater Birmingham Scheme included the annexation of Harborne but was opposed by Harborne's rate payers, as was a further scheme in 1889. However, in 1891 the inevitable happened and Harborne's rate payers voted in favour of annexation, no doubt

persuaded by the inducements offered and the fact that Birmingham's rates were now lower than Harborne's. Independence was finally at an end and the future of Harborne was to be as a thriving suburb of England's Second City. It also meant that Harborne was now 'officially' in Warwickshire.

Harborne today is still a very attractive place. It retains much of what gave it its character and charm. But most of all, it has retained a sense of identity and a sense of community. Harbornites, old and new, still talk of going down to the 'village' and the photographs chosen for the book try to capture something of the atmosphere and character of old Harborne by showing how it used to look and especially to act as a reminder of what has gone. The photographs are mainly chosen from the collection which has been built up over recent years at Harborne Library and in a sense this book is a thank-you and acknowledgement for the willingness of so many Harbornites to donate treasured photographs to the library so that they may be shared with other people and carefully preserved for future generations. The author would be delighted to hear from readers with other photographs or with memories to share !

Acknowledgements

The author would like to thank the following for their support and for permission to make use of their photographs:

Birmingham Library Services for material from the Birmingham Collection in the Central Library, the Birmingham Post and Mail for 53b and 80a, W. Camwell for 46a and 47b, L. Hyett for 116a, Miss T. Jones for 15, 111b, 116b and 118a, and Avery Berkel UK for 121b.

Mrs Betty Wright for material from the Donald Wright Collection housed at Harborne Library and Birmingham Library Services for other material from the Harborne Collection at Harborne Library.

Finally I would like to thank the people of Harborne who have donated the photographs that make up the Harborne Photographic Collection at Harborne Library and who helped to make this book possible.

One
Rural Past

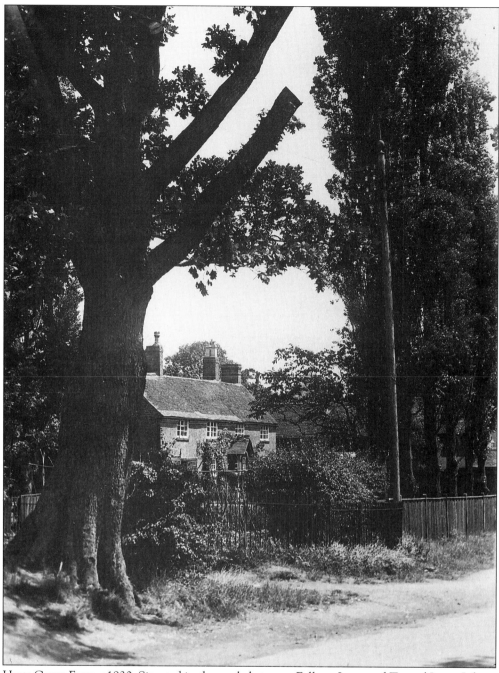

Harts Green Farm, *c*1930. Situated in the angle between Fellows Lane and Tennal Lane. It kept its dairy herd and the sale of fresh milk until the early 1930's. The farm house was demolished in 1934 as part of the Harts Green Estate development.

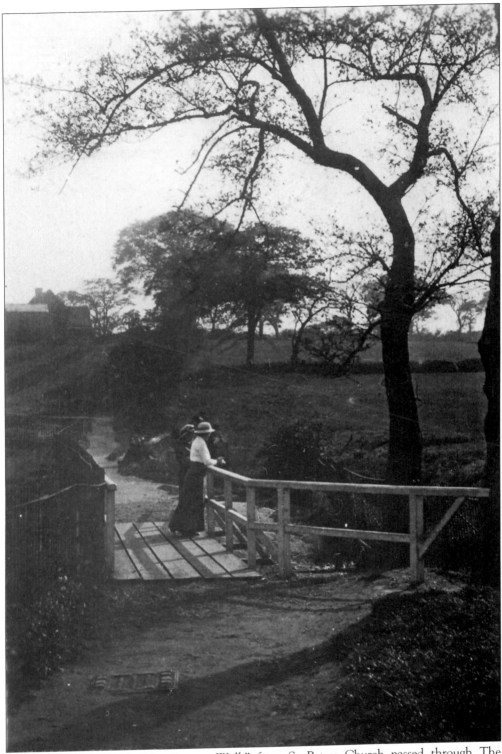

The Hillyfields, c1910. The "Lovers Walk" from St Peters Church passed through The Hillyfields, over the bridge and on to Weymoor Farm

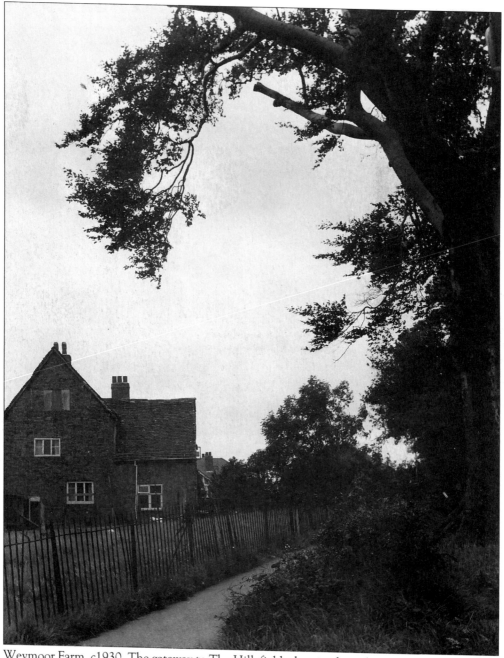

Weymoor Farm, *c*1930. The gateway to The Hillyfields showing how the Lovers Walk had been diverted and hedged in with iron railings.

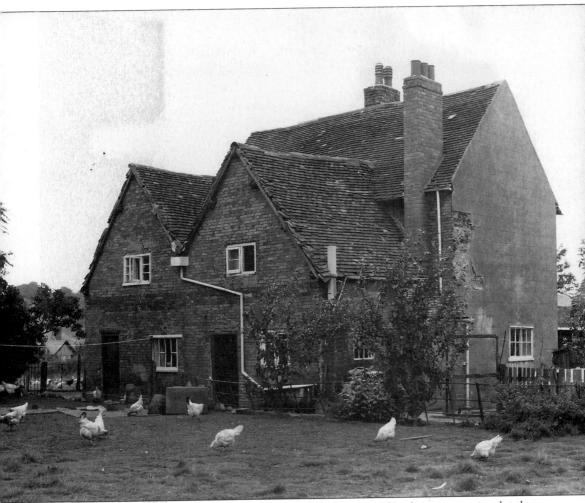

Weymoor Farm, 1957. Also called Whitehouses Farm because of its long occupation by that family. Farmed by the Stockton family from 1926 onwards. In 1932 most of the land was sold to Birmingham Corporation for housing although the farm house was occupied by the Stockton family until 1965 shortly before demolition. The name Weymoor was first mentioned as long ago as 1587 when the occupant appeared at Stafford Assizes.

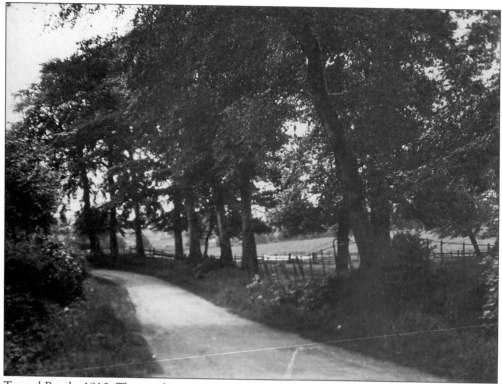

Tennal Road, *c*1910. The winding country lane that led from Harts Green to Tennal Hall and on to join the country road to The Quinton (now part of Hagley Road).

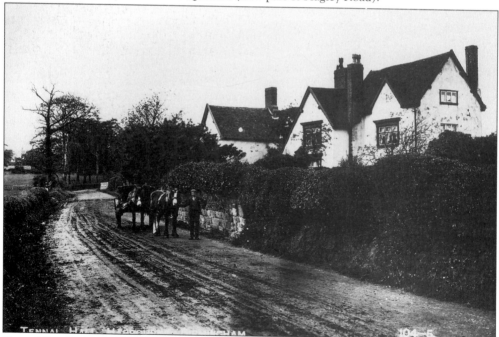

Tennal Road, *c*1910 showing the condition of Harborne's country lanes at the time. The horse and cart are passing in front of Tennal Hall.

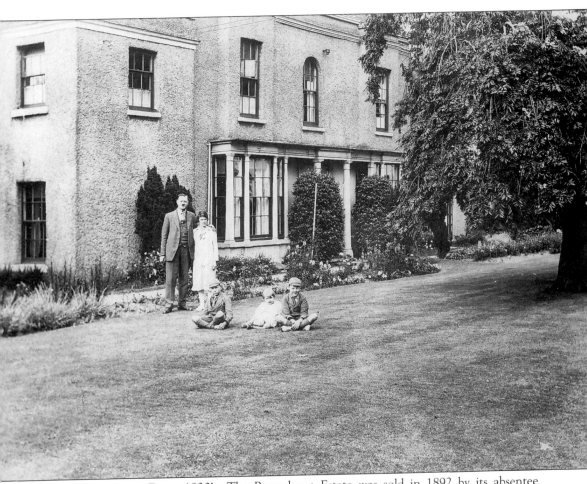

Upper Ravenhurst Farm, 1920's. The Ravenhurst Estate was sold in 1892 by its absentee landowner, General E.W.D. Bull, V.C., to Fr. Pereira (hence Pereira Road) of the Oratorian Fathers. Cardinal Newman was a visitor during his time at the Oratory and celebrated mass at the chapel in the farm house. In the 1920's it was a police sub-station occupied by Sergeant Jones and his family (photograph). The police station was to the right of the front door and the family occupied the other rooms. Three other local constables lodged upstairs. The fields that belonged to Upper Ravenhurst were for many years the playing fields of St Phillips Grammar School.

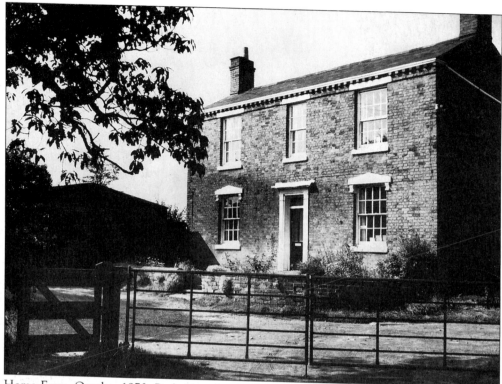

Home Farm, October 1970. Probably a late eighteenth century building with later additions. The farm and estate, situated off Northfield Road, were sold up in 1901 and much of the land is owned and used by the golf club. The southern part and the farm house is used as the West Midlands Police Dog Training Centre.

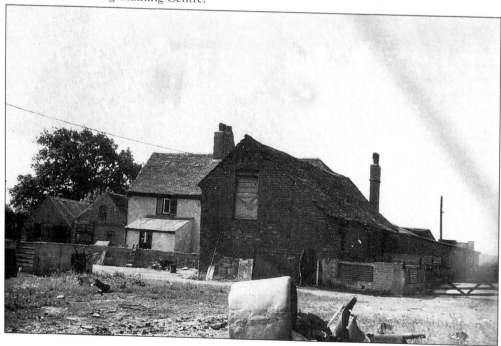

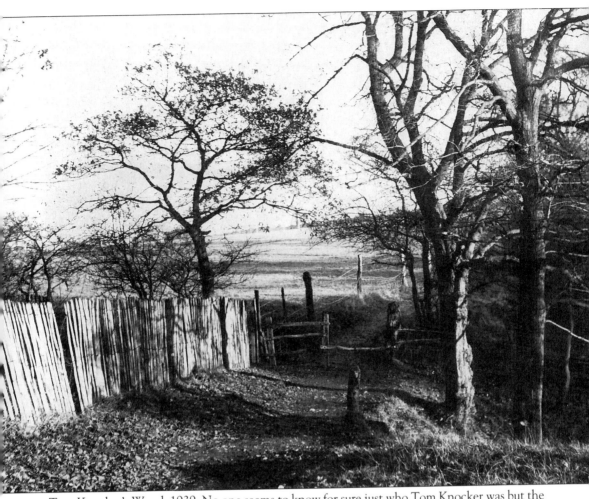

Tom Knocker's Wood, 1939. No one seems to know for sure just who Tom Knocker was but the story goes that he was an agricultural labourer who hanged himself in the wood and his ghost has haunted it ever since...It was situated around where the junction of Quinton Road West and West Boulevard now is. The wood was mostly felled in the mid 1930's prior to the building of the new estate.

Opposite: Welshouse Farm, 8 July 1962. For long the home of the Millward family. The farm house was situated on the edge of the golf course in what is now Welsh House Farm Road and wasn't demolished until the late 1960's.

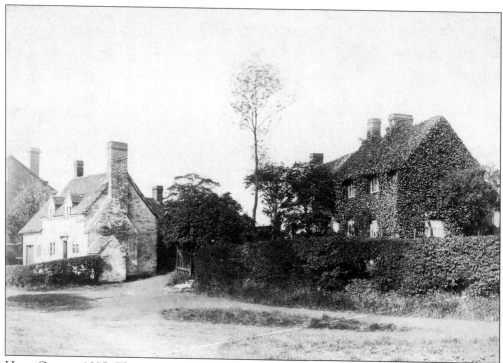

Harts Green, c1895. This was a small farming hamlet at the junction of Northfield Road and Tennal Road. Then a country crossroads, now a major traffic junction with two islands, shops and a pub.

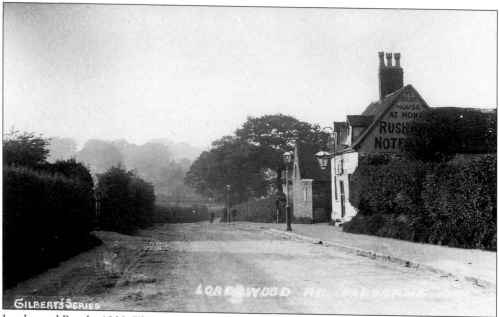

Lordswood Road, c1900. The original Old House at Home Pub was situated about 300 yards up the road from the present building. The remnants of Carles Wood are on the left of the photograph followed by Lords Wood in the distance extending as far as Beech Lane (now Hagley Road).

Harborne Tennants Estate about 1907 shortly before building started. Note the railway bridge in the background.

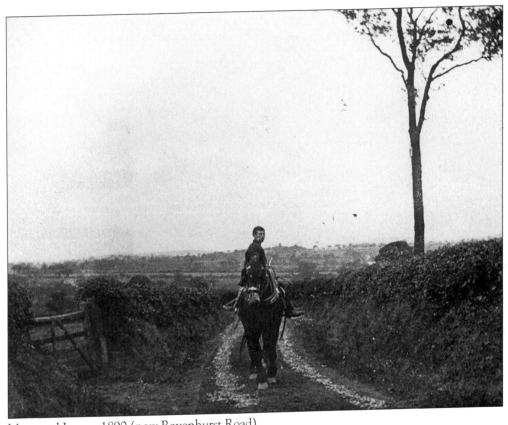

Moorpool Lane, *c*1890 (now Ravenhurst Road).

Mr Dodds, the Pitts Wood keeper, c1895. Pitts Wood was just over the Harborne boundary into Quinton near what is now the start of Ridgacre Road.

The Moorpool, c1905. Where moorhens and snipe had their haunts and from which in earlier days the village drew its supply of water in carts. The washer women of the village no doubt were heavy users for as the jibe went, "Hungry Harborne proud and poor, a washer woman at every door". Many of their customers were no doubt in Harborne's more affluent neighbour, Edgbaston.

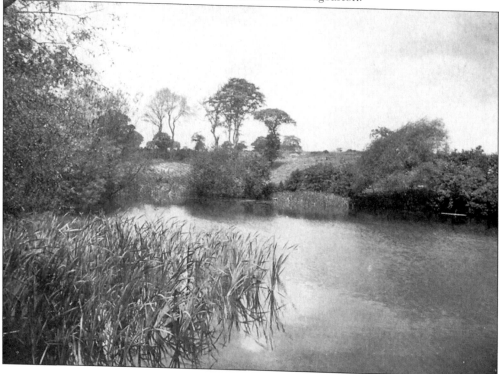

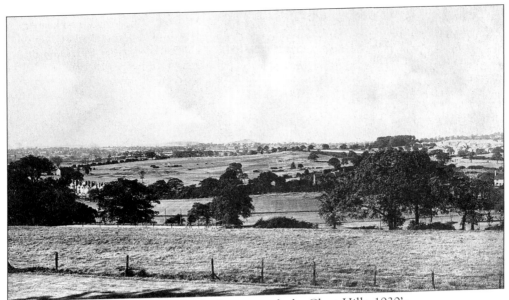

View from St Peters vicarage garden looking towards the Clent Hills, 1930's.

Reservoir Lane (1), c1910. Popularly called Love Lane in summer and Mucky Lane in winter, it ran from near Harborne Hall to the banks of the reservoir which was built to safeguard the water supply of the local mills. Now called Grove Lane. The reservoir has since been filled in and partly built over.

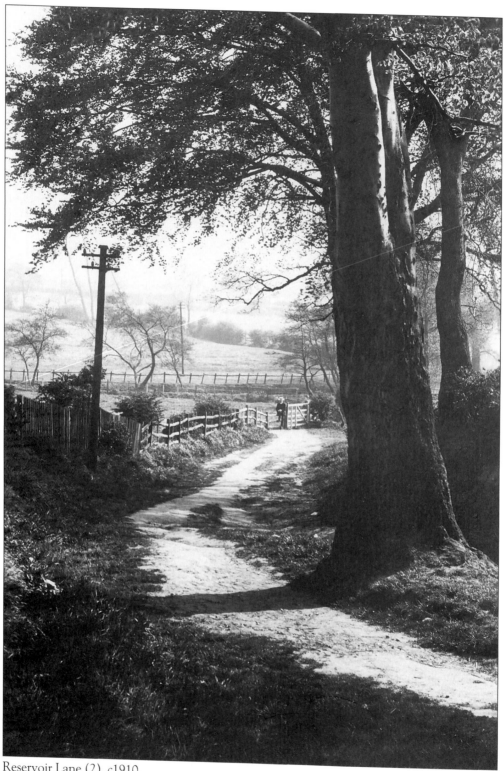

Reservoir Lane (2), c1910.

Two

Houses and Housing

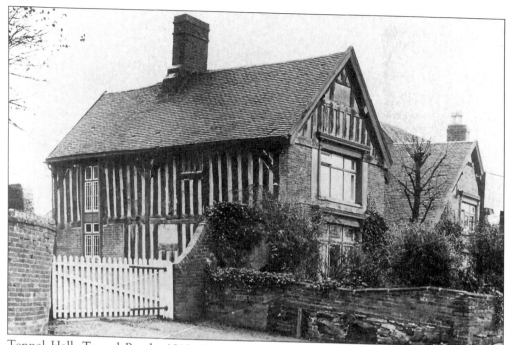

Tennal Hall, Tennal Road, c1910. Dating back to Elizabethan times, it has the inevitable legend that Good Queen Bess slept here. An unlikely story, what is true is that in the 1750's it was the home of farmer Job Freeth, said to be Harborne's biggest man at forty stone. More recently farmed by the Pearman family, it was demolished in 1937.

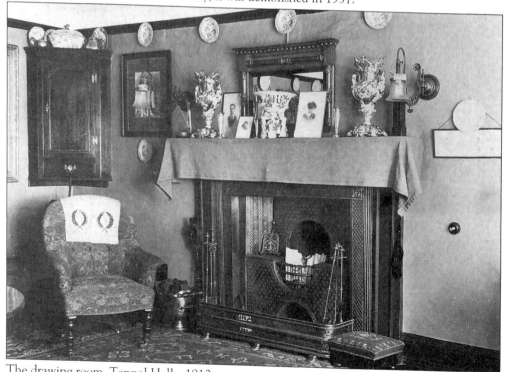

The drawing room, Tennal Hall, c1910.

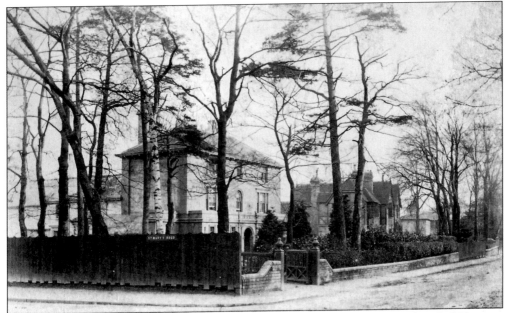

Field House, Harborne Park Road, c1890. One of Harborne's few remaining listed old houses. The present house was probably built in the late eighteenth century, but around the core of an earlier timber framed building. In the drive of the house is a well which it has been suggested may date back to Roman times, but this has yet to be proved.

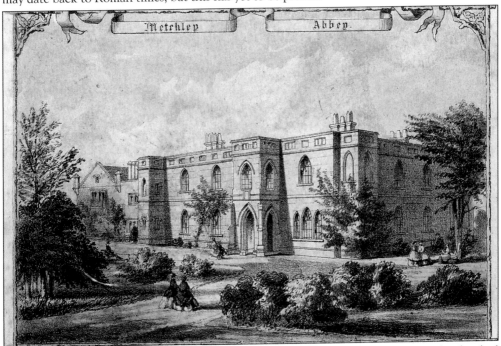

Metchley Abbey, Metchley Lane, from a nineteenth century print. A rambling and individual house. Little is known of its early history. Edward Freeman, the historian, was born here in 1823. Occupied for many years by Sir Henry Wiggin, the well known Birmingham industialist. Now sheltered housing.

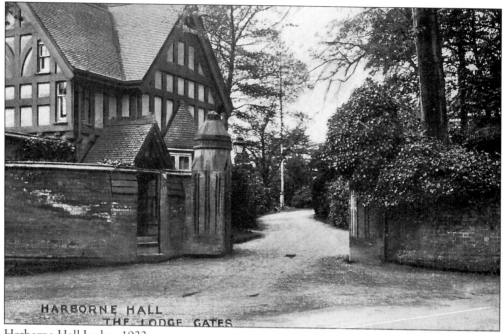

Harborne Hall Lodge, 1922.

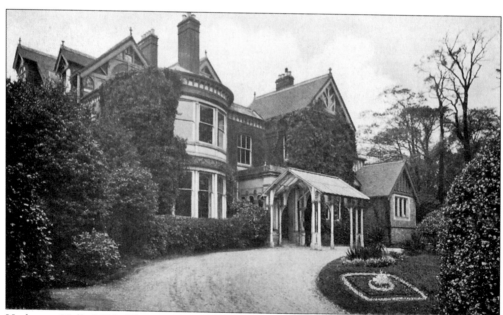

Harborne Hall, 1922. The present building dates back to the mid nineteenth century, but stands on the site of a much older building. It was rebuilt by Dr Hart, the founder of the Harborne Volunteer Fire Brigade, and later the home of Walter Chamberlain (1884 — 1901). Popularly remembered as a convent and more recently as the Multi-Faith Centre.

Stapylton House, Old Church Road, 1966. Built about 1840 by the Rev. James Towry Law, the vicar of Harborne, for his curate the Rev. Stapylton Bree. Demolished in 1966 and Stapylton Court built on the site.

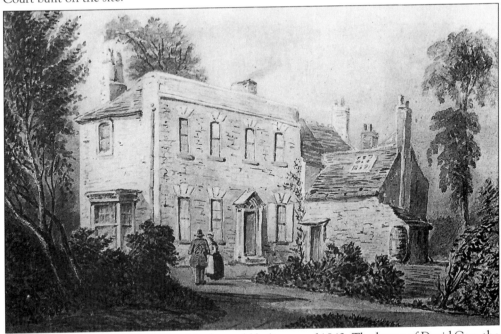

Greenfield House, Greenfield Road from an old heliotype of 1842. The home of David Cox, the famous water colourist, from 1841 — 1859. It was sympathetically restored in 1984 after a long period of neglect and bears a Birmingham Civic Society plaque to commemorate its association with Cox.

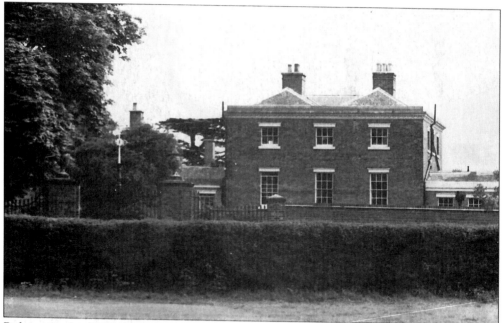

Bishops Croft, c1960. Built about 1790 by Squire Thomas Green soon after he purchased the manor of Harborne. Purchased in 1921 by the Church Commissioners as the official residence of the Bishops of Birmingham. Renamed Bishops Croft.

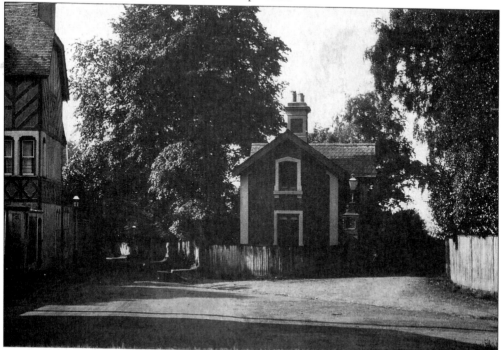

The Old Lodge to The Grove, c1920. Home of Thomas Attwood, Birmingham's first M.P. The house and estate (now Grove Park) were presented to the City of Birmingham by the Kenrick family in the 1930's. House demolished in the 1960's although the anteroom was rebuilt in the Victoria & Albert Museum (the Harborne Room).

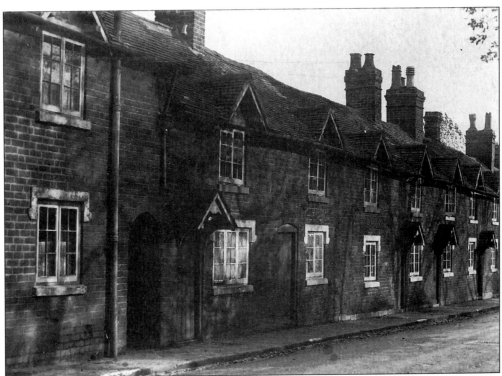

Cammomile Cottages, Tennal Road, *c*1900. Former nailmakers cottages, situated in an area known as Cammomile Green, they were demolished in the mid 1930's.

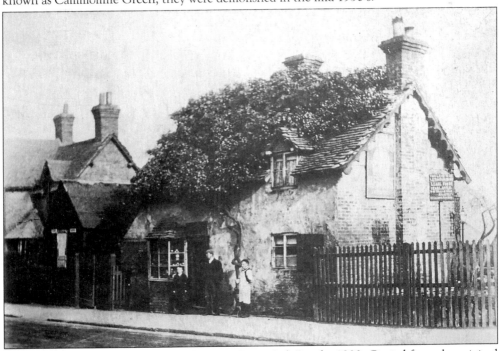

Sally Taylor's cottage, said to have been in Court Oak Road, *c*1900. Copied from the original photograph which appeared in Presterne's well known book about Harborne.

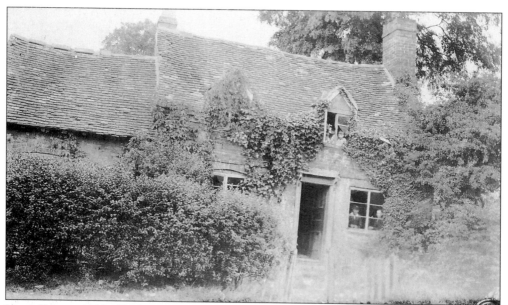

Harts Green, c1930. Old farm workers cottage near Harts Green Farm, on the corner of Tennal Road and Northfield Road. Note the childrens faces in the windows. Demolished in 1936.

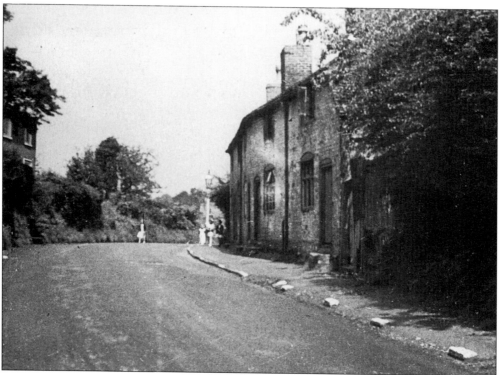

Crumpton's Row, Northfield Road. Named after Arthur Crumpton, the grave digger at St Peters Church, who was born and spent his entire life in the end one. Demolished about 1937.

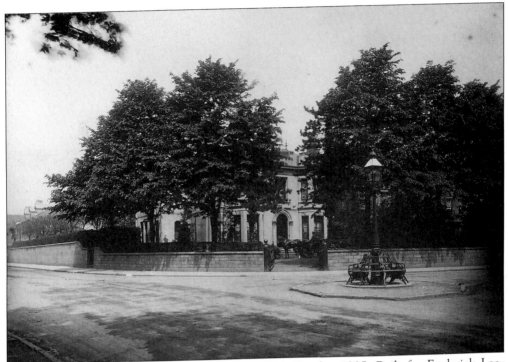

Craigellachie, corner of Vivian and Harborne Park Roads, c1905. Built for Frederick Lee-Strathy in what was then Lodge Road.

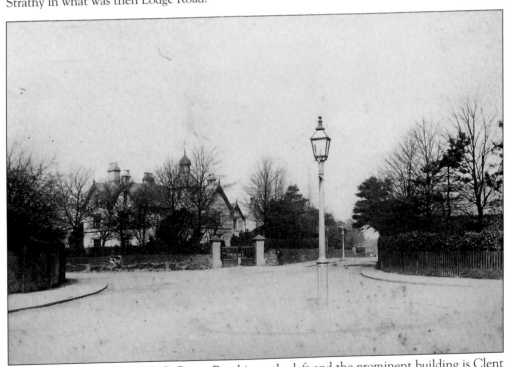

Harborne Park Road, c1890. St Peters Road is on the left and the prominent building is Clent House, long demolished.

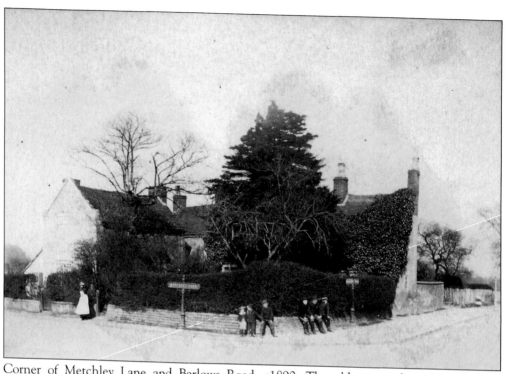

Corner of Metchley Lane and Barlows Road, c1890. The old county boundary between Staffordshire (Harborne) and Warwickshire (Edgbaston) followed Metchley Lane.

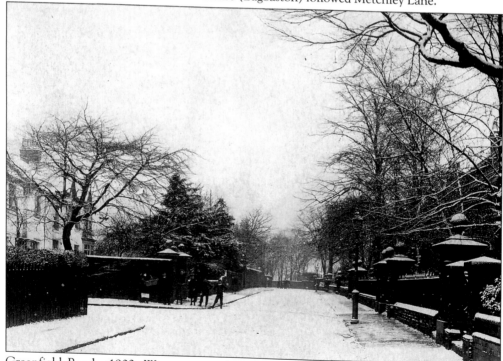

Greenfield Road, c1900. Winter scene showing Greenfield House on the corner of South Street.

20-24 High Street, 7 October 1952. A reminder that this end of the High Street (formerly Heath Road) was originally mainly residential. Buildings now occupied by Fishers, the estate agents.

79 High Street, c1950. Near the corner of St Johns Road. A doctors surgery since the turn of the century, it was for many years the home and surgery of Dr McCook, a much respected local G.P. Houses demolished in 1965 and replaced by The Parade.

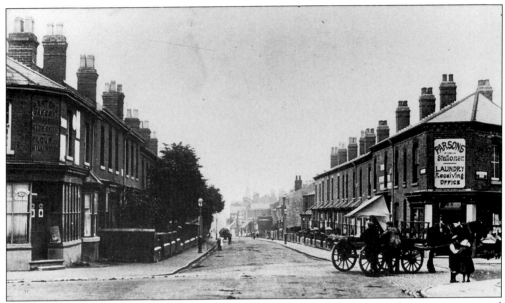

Vivian Road at Greenfield Road junction, c1905. West End bakery on the one corner, and Parsons Stationers opposite. The blue enamel street plate on Parson's building is now one of the few still remaining in Harborne. Note the profuse evidence of horse transport !

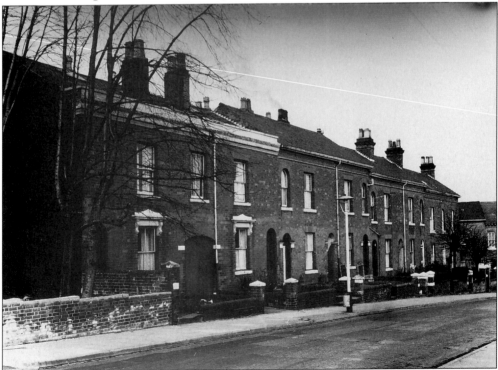

St Johns Road, April 1968, showing how little these Victorian buildings had changed over the years. The photograph also shows the way in which many of Harborne's Victorian roads were built piecemeal in small blocks of houses, with very few identical to each other. This adds much to the charm and character of Harborne's Victorian core.

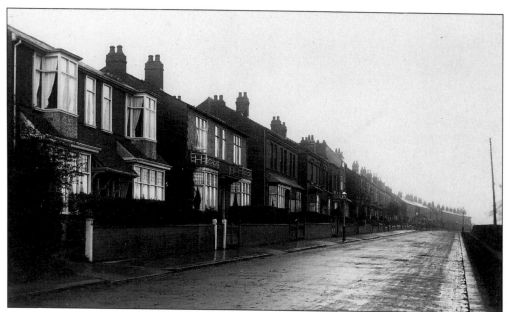

Wood Lane, c1910. Previously called Still Waters Lane. To the right of the view is the campus of the Queen Alexander College and the Birmingham Royal Institution for the Blind.

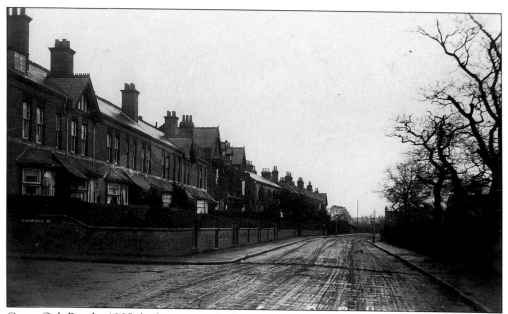

Court Oak Road, c1905, looking towards the village. Woodville Road is on the left, while the house situated to the right was for many years the Harborne Collegiate School, a much respected institution, which finally closed in 1961.

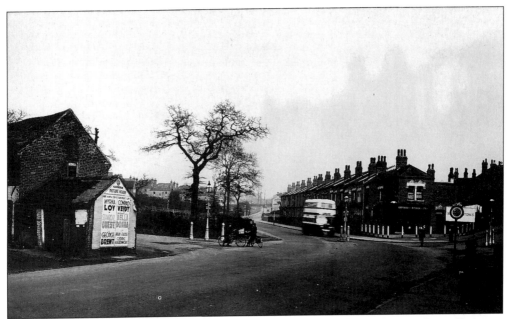

Northfield Road/War Lane junction, 7 March 1935. The outbuildings of Harts Green Farm, on the left were advertising the Harborne Picture House in Serpentine Road (now the Village Social Club), Harborne's first cinema.

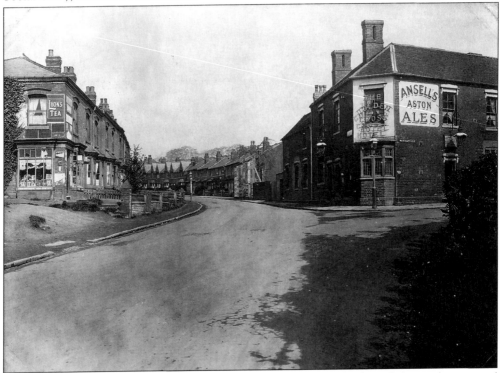

Harborne Park Road, 7 May 1924, before the council estate was built, and the road converted to a dual carriageway. The Golden Cross on the corner of Metchley Lane has since been rebuilt and recently renamed the Lazy Fox.

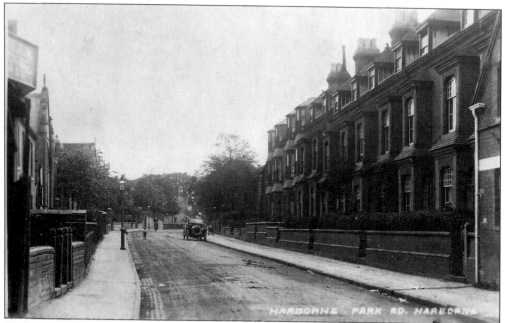

Harborne Park Road, c1910. The village end was originally called Poyners Lane. Renamed Park Road after a large residence of that name. The Harborne prefix was added later to avoid confusion with other Park Roads in Birmingham.

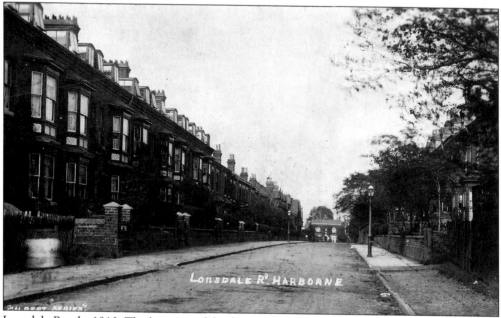

Lonsdale Road, c1910. The location of the first purpose built bus garage in Birmingham, which opened in 1926. It closed in 1986 and the site redeveloped.

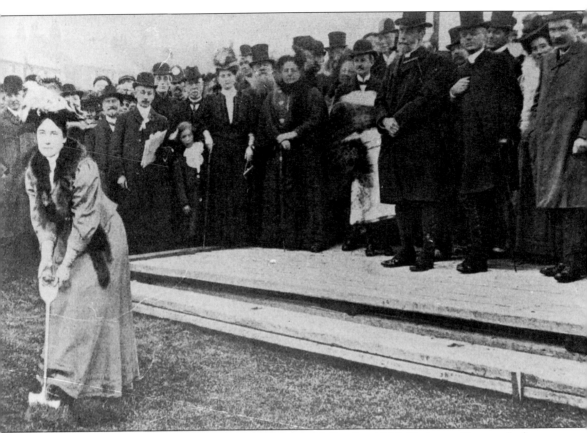

Harborne Tenants Estate, cutting of the first sod, 26 October 1907. Harborne Tenants Ltd was based on the co-partnership principle whereby tenants would take up shares in the company and ultimately have a controlling intesest in it, and its aim was to provide better homes with gardens, more open spaces and playgrounds for children, and with rents within the means of workman and artisans. The ceremony of the cutting of the first sod was carried out on by Mrs J.S. Nettlefold in the presence of an interested company of 200 spectators. The ceremonial trowel was presented to Mrs Nettlefold and can be seen in the offices of Harborne Tenants Ltd. Building operations commenced on the 1 January 1908.

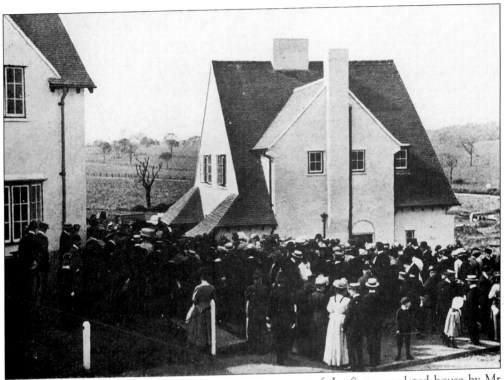

Harborne Tenants Estate, the official opening ceremony of the first completed house by Mr Henry Vivian, M.P. on 24 May 1908.

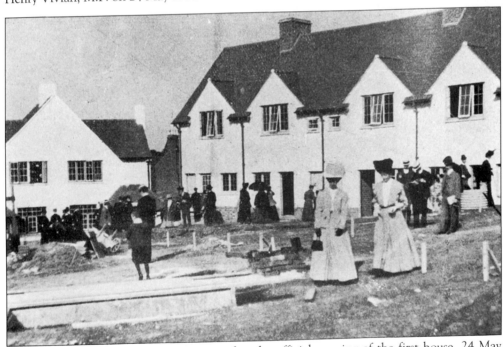

Harborne Tenants Estate, tour of estate after the official opening of the first house, 24 May 1908.

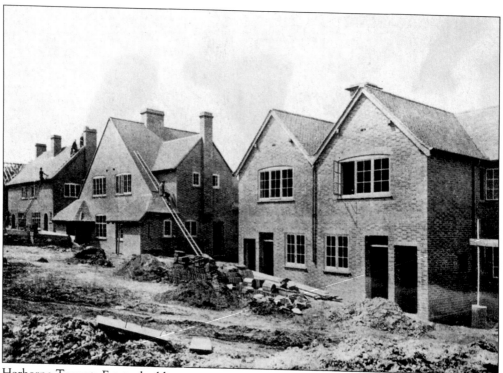

Harborne Tenants Estate, building operations 1908. The houses shown show something of the variety of designs used, which adds so much to the attractiveness of the estate.

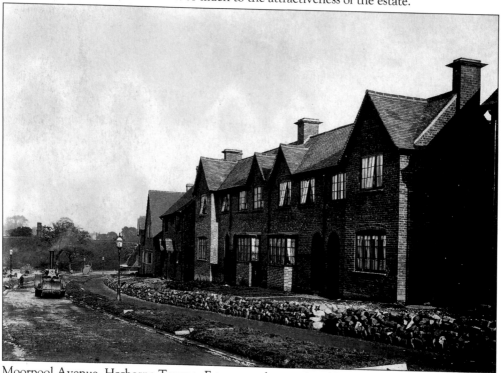

Moorpool Avenue, Harborne Tenants Estate, nearly completed houses 1908.

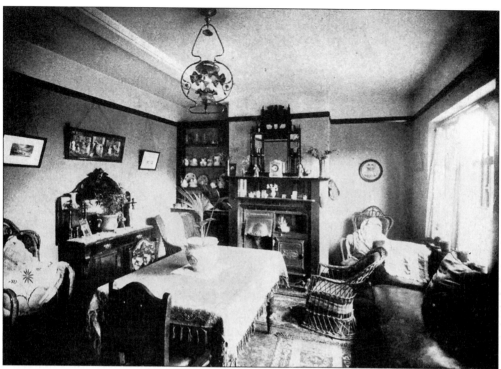

Harborne Tenants Estate, "cottage" interior, 1909.

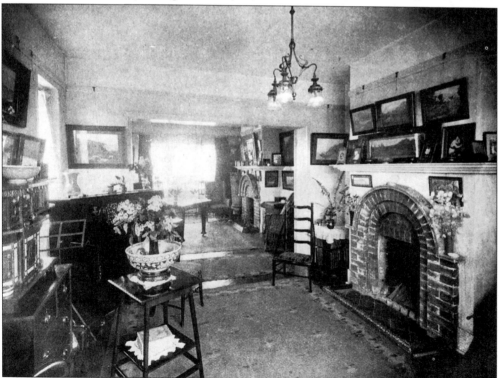

Harborne Tenants Estate, another interior view, 1909.

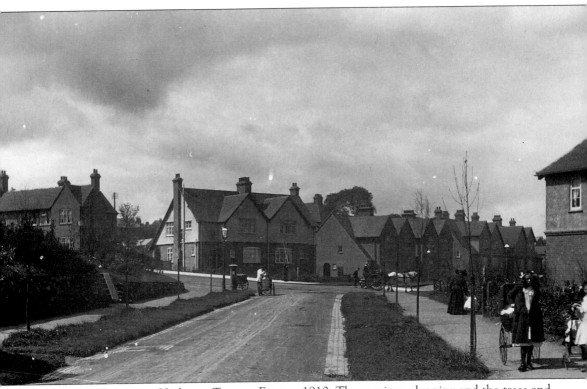

Moorpool Avenue, Harborne Tenants Estate, c1910. The spacious planning and the trees and grass verges contrasts dramatically with what was being built in many other parts of the city at the time.

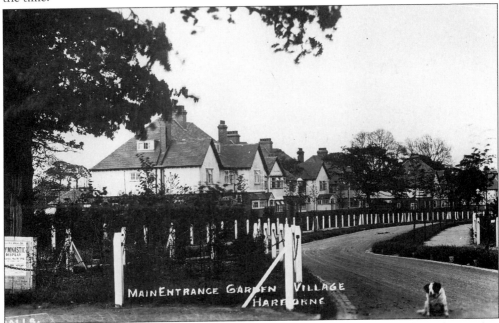

Harborne Tenants Estate, an early view on the estate showing the post and chain fences that were a feature for a time.

Three
Harborne Railway

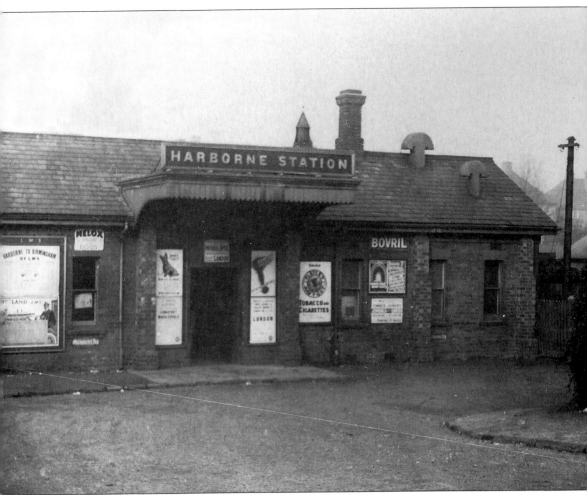

Harborne Station, 1934. The Harborne Railway Co. originally intended to build a branch line through to Halesowen but authority was only given as far as Harborne. The line was worked by the LNWR from its opening on 10 August 1874 and the initial service of six trains a day was later to reach a peak of over twenty. After the First World War traffic declined and the passenger service was withdrawn in November 1934. Goods service continued until final closure in November 1963. Intermediate stations were provided at Ichnield Port Road, Rotton Park Road and Hagley Road. A spur to the Cape Hill Brewery was later installed.

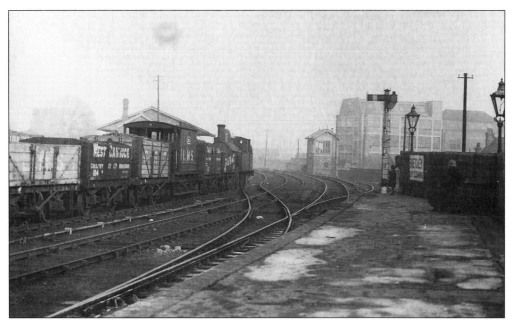

Harborne Station yard from platform, 1934. Goods and coal traffic was considerable in pre-war days when every house had an open fire and most heavy goods travelled by rail. There was also a siding into the City Engineers's depot in Rose Road. The large factory in the background is Chad Valley Toys. The signal box nameplate is now on display at Harborne Library.

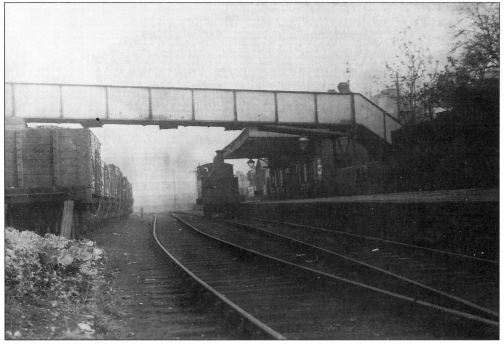

Harborne Station from the turntable, 1934. The bridge was provided for the convienience of passengers from the Harborne Tenants Estate to the station approaches. The railway authorities wanted to remove the bridge after cessation of the passenger service but a vigourous local campaign was successful. There is still a right of way along the same alignment.

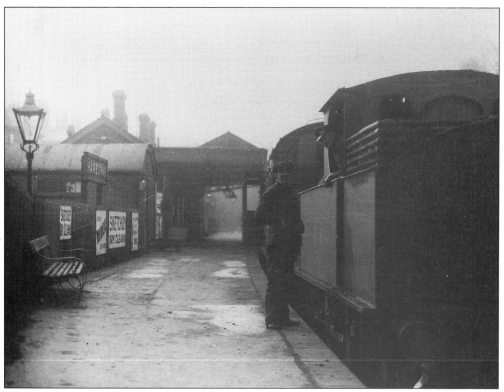

Harborne Station, 1934. View of passenger train at the platform. The mainstay of the passenger workings were the old ex-LNWR Webb Coal Tanks or "Cauliflowers".

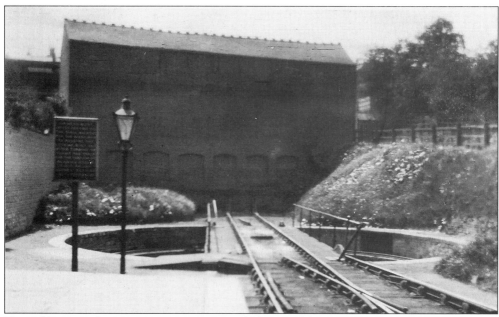

Turntable at Harborne Station, 1929. Provided to enable engines to turn around and face forward for the return journey. It was removed in 1949 as redundant.

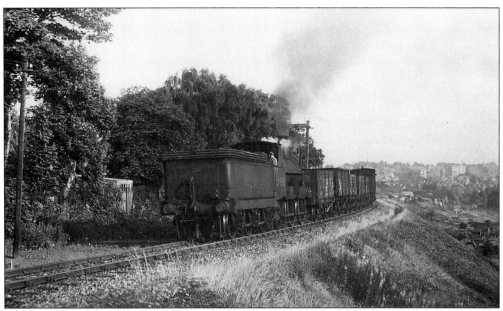

Chad Valley embankment, 1 July 1949. Ex-LMS engine 28616 pulling a goods train on the 1 in 66 incline between Harborne and Hagley Road stations.

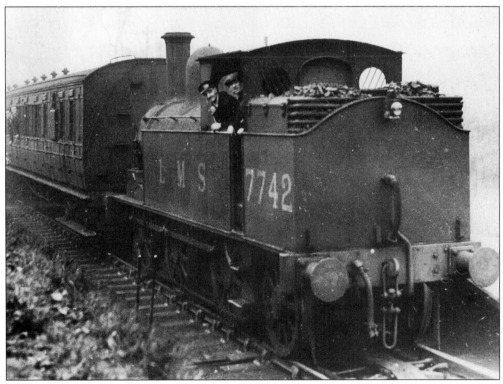

Hagley Road Station, 24 November 1934. LMS 7742 at Hagley Road during last month of passenger operation.

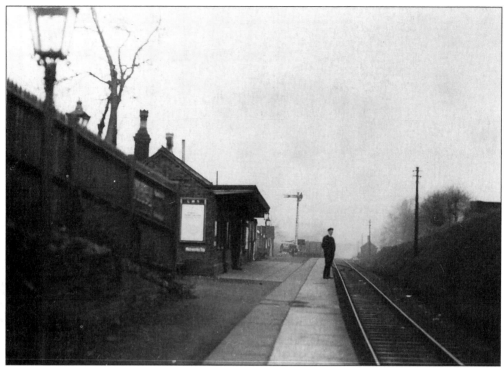

Hagley Road Station, 1934. The passenger service was complimented by a small goods yard off a loop, which was heavily used by local coal merchants.

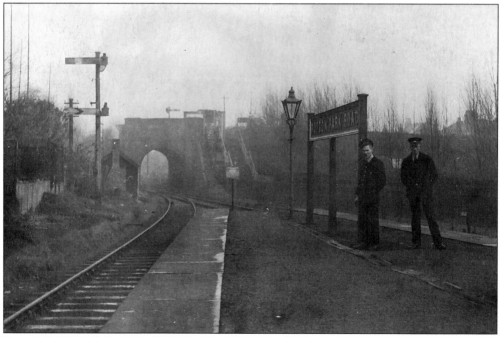

Rotton Park Road Station, 1934. Converted to an island station in 1909 and a passing loop installed. At the same time a spur to the Cape Hill Brewery was installed from near the Harborne end of the platform A ground frame was situated on the platform.

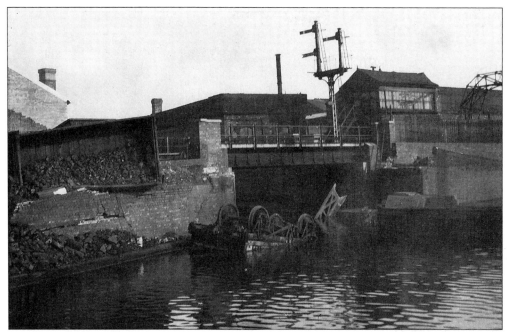

Accident, 31 October 1953. There were only two recorded accidents on the line, both caused by runaway wagons. On the second occasion, in 1953, ten wagons and a brake van careered down the line, over the catch points protecting the main line, and into the buffers. Some of the wagons ended up in the canal.

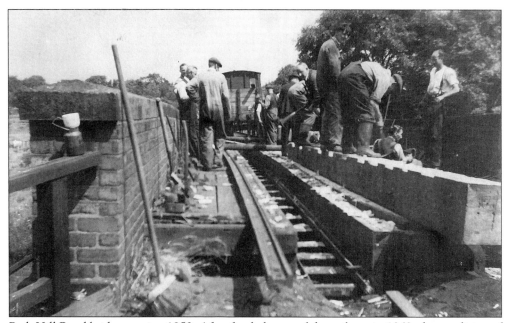

Park Hill Road bridge repairs, 1953. After final closure of the railway in 1963, the condition of the bridge deteriorated and plans were afoot to demolish it. A vigorous local campaign prevented this. Restoration has recently taken place and the bridge remains as a fitting reminder of the old Harborne Railway.

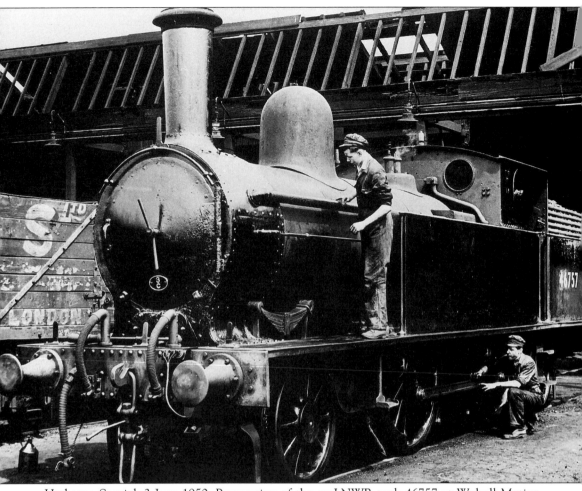

Harborne Special, 3 June 1950. Preparation of the ex-LNWR tank 46757 at Walsall Motive Power Depot for hauling the Stephenson Locomotive Society Special up the Harborne Branch later that day. The Special ran from New Street Station, via Monument Lane Station before leaving the main line at Harborne Junction. It was the first of a number of specials to visit the branch before final closure.

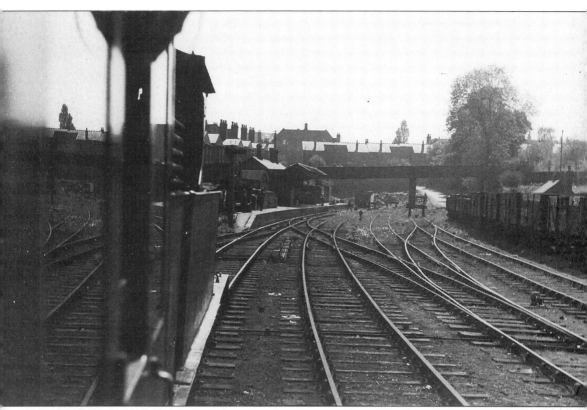

Harborne Special, 3 June 1950. The Special entering Harborne yard mid-afternoon, showing the yard layout. Little had changed over the years since cessation of the passenger service, other than the removal of the turn table.

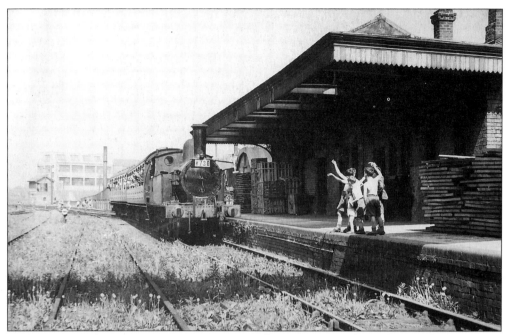

Harborne Special, 3 June 1950. Coming into Harborne Station. The neglect of the track since the passenger service was withdrawn is very apparent.

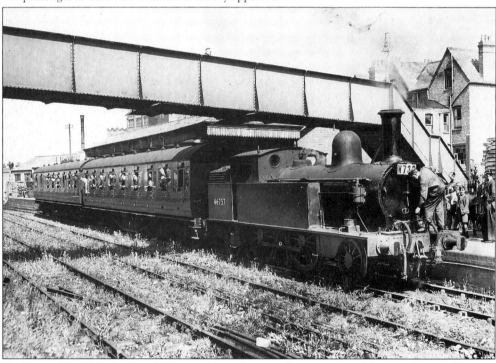

Harborne Special, 3 June 1950. Note the enthusiasts hanging out of the windows. Old trains and railways were as popular a passion in 1950 as they are now. The Special was run on the distinct understanding that passengers did not alight from the train at Harborne Station, but they were allowed to retain their tickets as a souvenir.

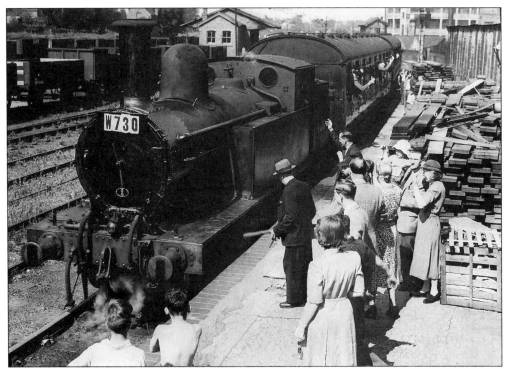

Harborne Special, 3 June 1950. The station buildings were at this time being used by the Chad Valley Toy Co. for storage, hence the crates on the platform. The Special was an event of importance in the village and hundreds of people lined the route at vantage points to welcome the first passenger train for nearly twenty years.

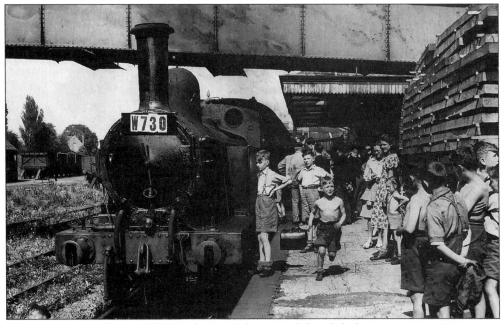

Harborne Special, 3 June 1950. Final view of the Special shortly before returning to Monument Lane. Note the baggy short trousers of the boys so typical of the period !

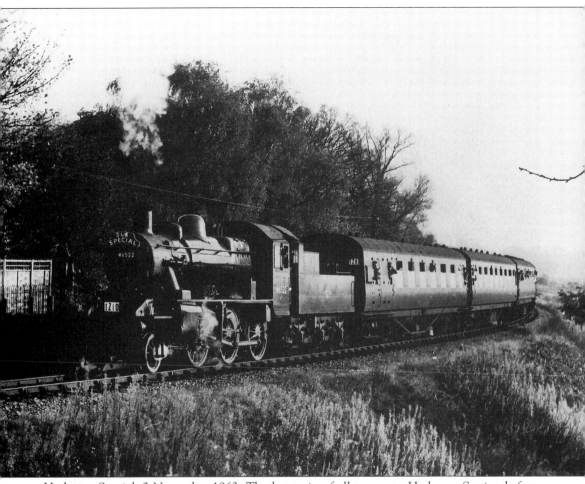

Harborne Special, 2 November 1963. The last train of all to run to Harborne Station before final closure and dismantlement was another S.L.S. Special. It left New Street Station at 1.25pm crowded with over 300 enthusiasts. The six coach train was powered by a Class T 2-6-0 tender engine at each end. Maximum permitted speed was 5mph !

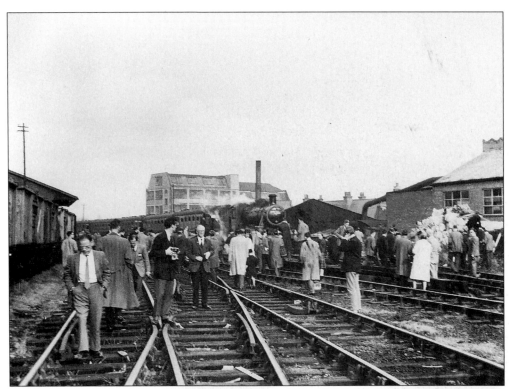

Last train at Harborne, 2 November 1963. On this occasion passengers were permitted to alight and take photographs and mingle with the crowd that had come to see the last train off. Chad Valley factory in the background, another local landmark that was also shortly to vanish.

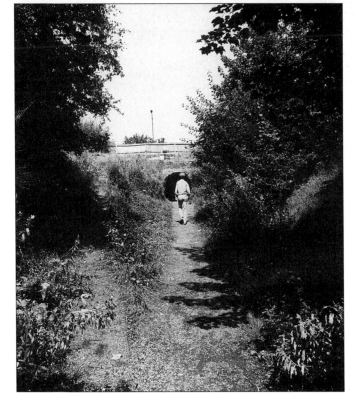

Harborne Walkway, August 1982. After the railway was closed in 1963 it was simply abandoned and rapidly became an almost inpenetrable jungle of birches, brambles and sycamores. In 1981 the old trackbed was cleared and the Harborne Walkway was formally opened later that year.

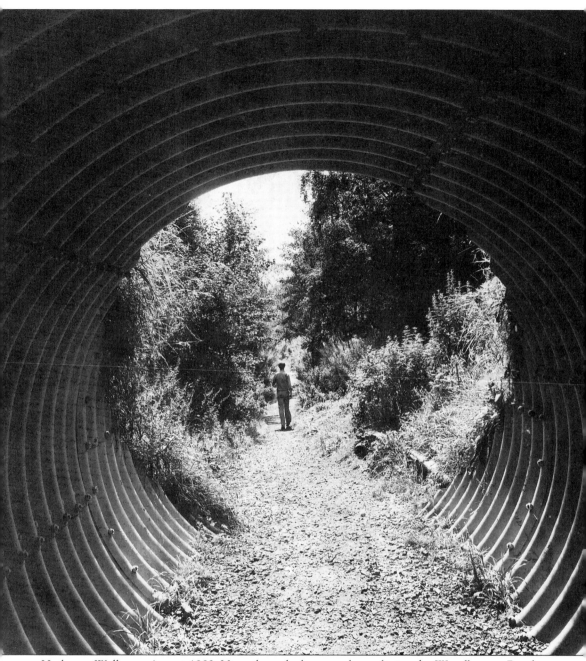

Harborne Walkway, August 1982. View through the tunnel now lining the Woodbourne Road bridge. The walkway has recently been extended over the renovated Park Hill Road bridge to provide a more attractive approach.

Four
Work and Trade

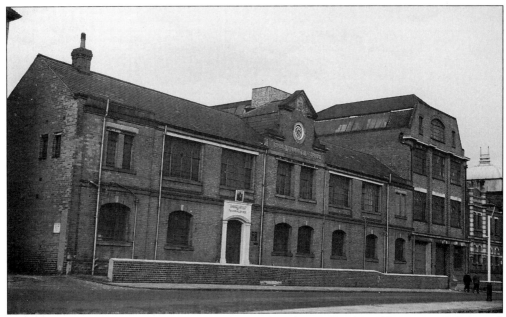

Chad Valley Works, Rose Road, 7 November 1964. Johnson Brothers (Stationers & Printers) moved to the newly built Chad Valley Works in Harborne in 1897. Extensions and a new factory were built on the site in the 1920's and the company was reorganised as Chad Valley Toys.

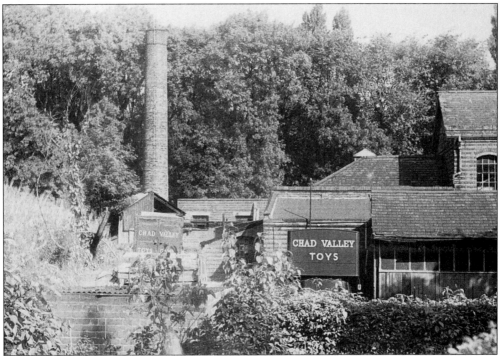

Wee-Kin Works, Park Hill Road, 1965. The old Mirror Laundry site was taken over by Chad Valley in 1954. Chad Valley's links with Harborne continued until 1972 when the Harborne factories were closed and production moved elsewhere.

Harborne Institute, Station Road, c1970. The foundation stone of the "literary and scientific" institute was laid by Sir Henry Irving the actor in 1878. After closure in 1904, the building was acquired by Chad Valley and fitted out as their printing works.

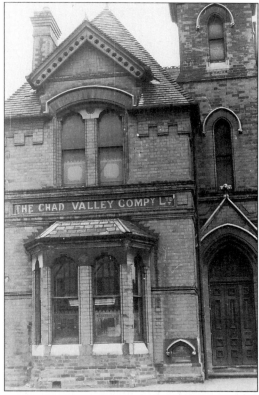

Chad Valley Works, c1900. The age of the girls and the belt driven open machinery is typical of the period. Possibly shows machine stitching.

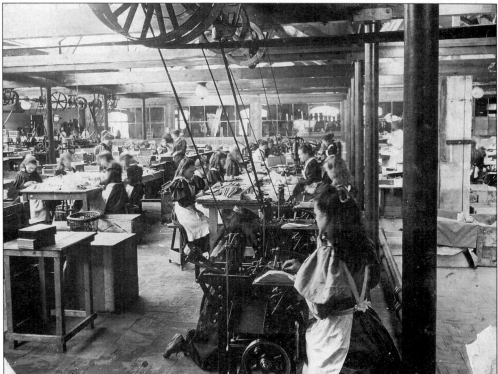

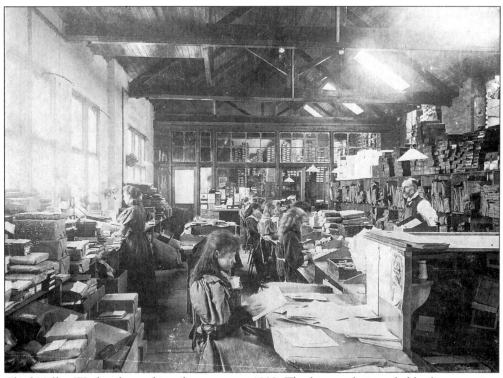

Chad Valley Works, the packing department, c1900. The lone male is probably the supervisor at a time when equal opportunity was an unknown concept.

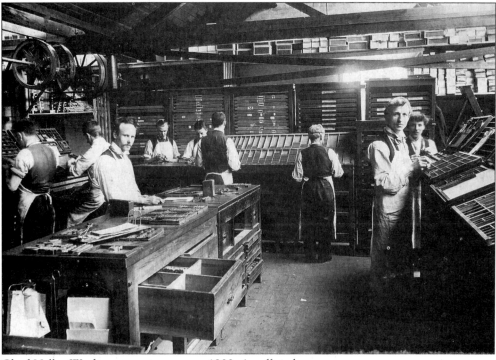

Chad Valley Works, composing room, c1900. An all male preserve.

Chad Valley Works, c1935. One of a series of official Great Western Railway photographs showing progression of GWR jigsaws through the production process. By this time soft toy production had been transferred to the Wrekin Toy Factory at Wellington.

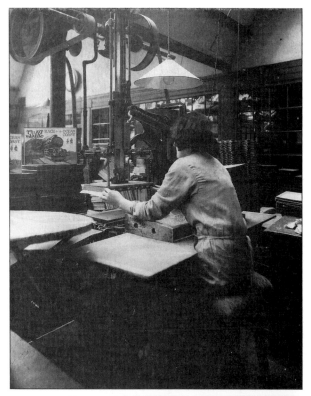

Chad Valley Works, c1935. Another official Great Western Railway photograph. Note the GWR jigsaws prominently displayed.

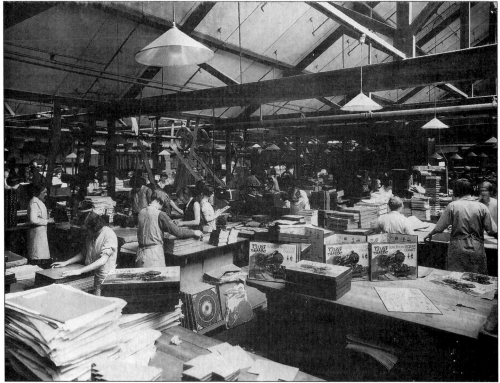

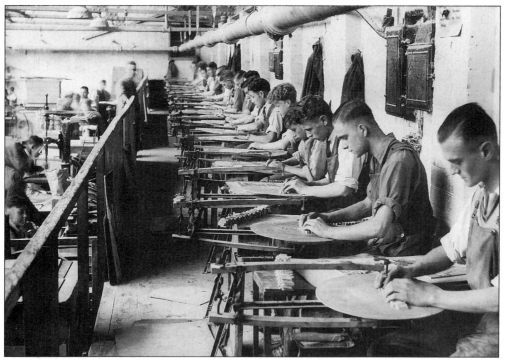

Chad Valley Works, *c*1950. Cutting batches of jigsaws by hand. Great skill and concentration was required.

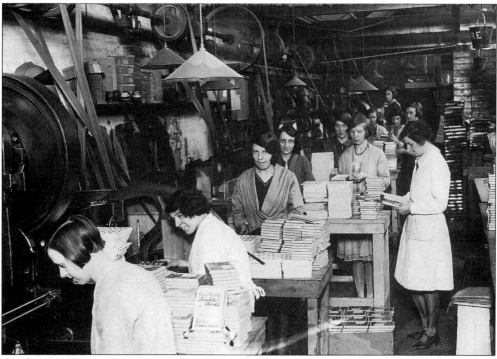

Chad Valley Works, 1930's. Daily Mirror photograph, again part of a series showing production of a a Daily Mirror promotion in the factory.

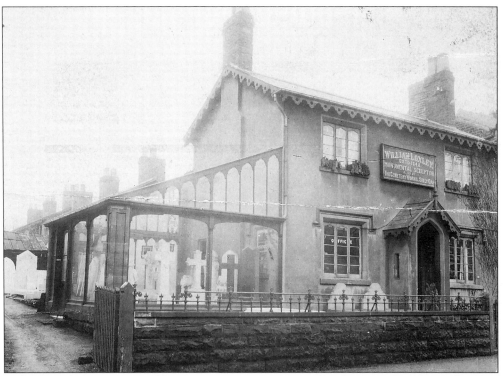

William Loxley, Monumental Sculpture, *c*1920. Counc. Loxley represented Harborne for many years on the City Council and was very involved in the life of the community. His office and works were situated in Greenfield Road near the Royalty Cinema.

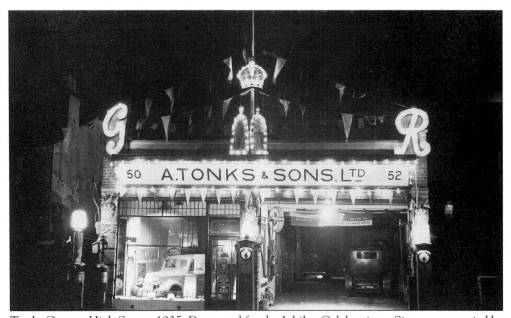

Tonks Garage, High Street, 1935. Decorated for the Jubilee Celebrations. Site now occupied by Lingfield Court (opposite North Road).

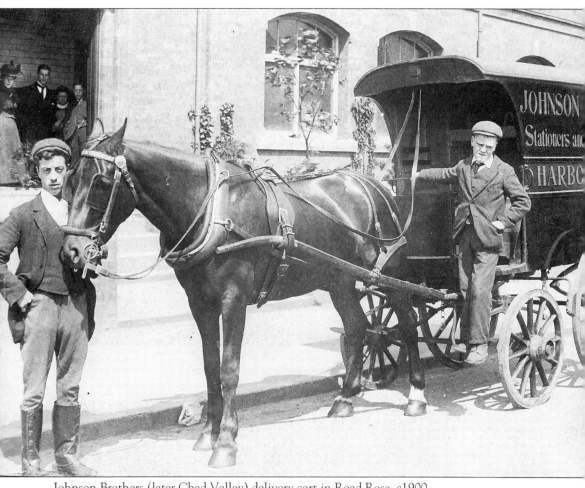

Johnson Brothers (later Chad Valley) delivery cart in Road Rose, *c*1900.

Opposite: Harborne Horse Bus, *c*1905. If the horse bus was full, difficulties could be experienced getting up Harborne Hill, and some of the gentlemen passengers might be asked to walk to the top. Harborne Hill was originally called Love Hill.

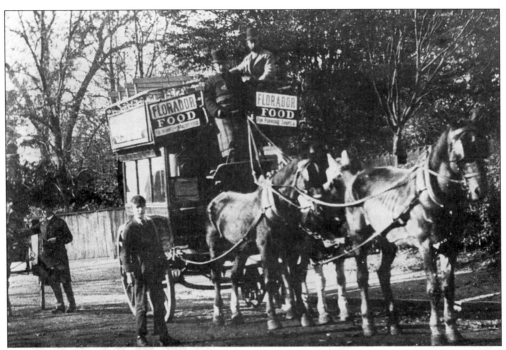

Harborne Horse Bus, c1900. Open topped and drawn by four horses. The horse bus lasted longer in Harborne because of the difficulties experienced by early motor buses getting up Harborne Hill.

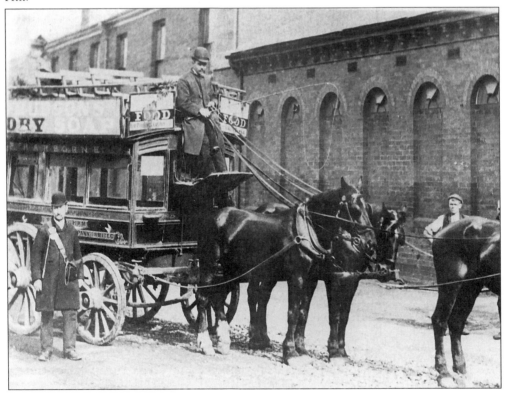

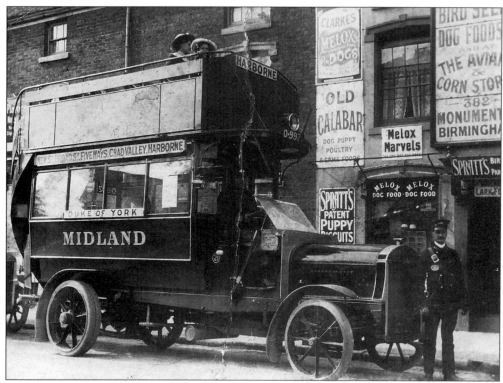

Early Motor Bus, High Street, c1913. Note the solid tyres and lack of protection for the driver from the weather. Still open topped.

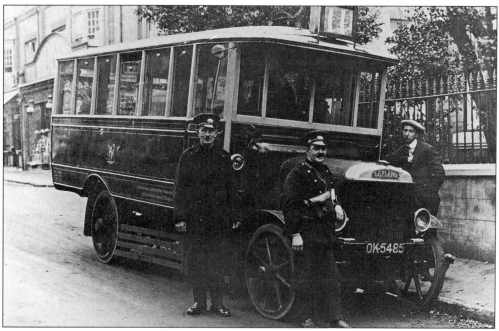

Motor bus, 1922. Albert Road/War Lane junction.

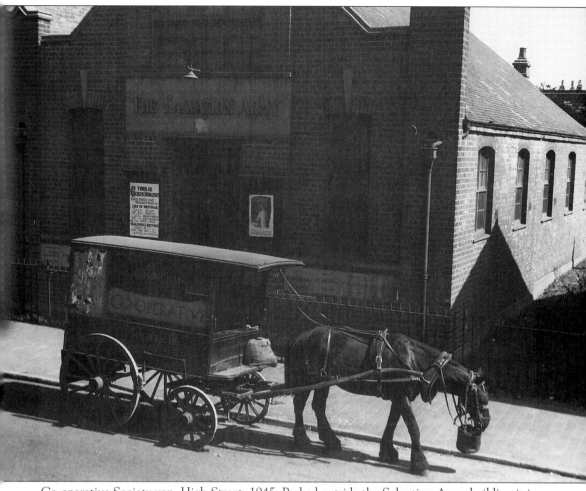

Co-operative Society van, High Street, 1945. Parked outside the Salvation Army building it is a reminder that horse transport for deliveries lasted until well after the Second World War. The Birmingham Co-operative Society was well represented among the shops on the High Street at the time. All have now closed.

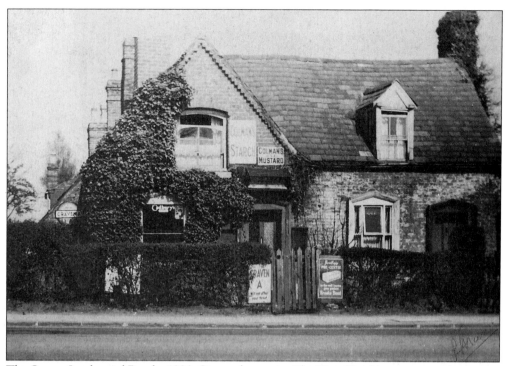

The Stores, Lordswood Road, c1930. Situated opposite Elm Tree Road in a converted cottage.

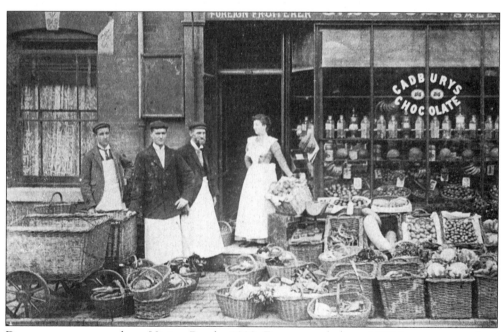

Douces greengrocers shop, Vivian Road, c1900. First opened about 1880 it was to remain a family concern for over a hundred years.

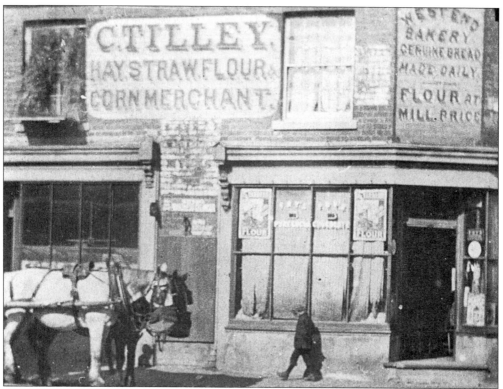

Vivian Road/Greenfield Road corner, c1890. All Electric Garage now occupy the Greenfield Road corner.

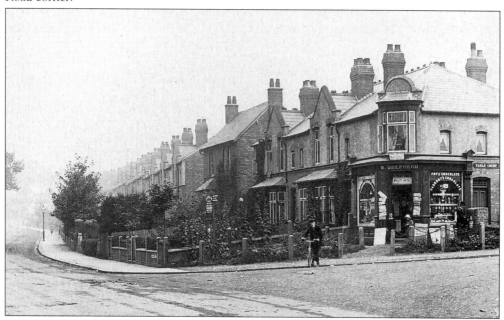

Court Oak Road (corner of Earls Court Road), c1910. A reminder that although trade was concentrated on the High Street, Harborne also had it's corner shops. This one was also a sub-post office.

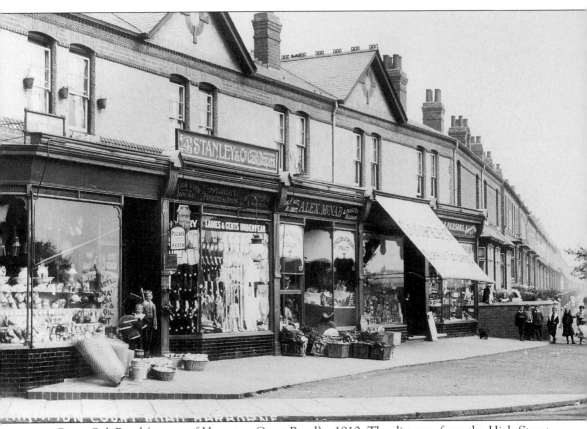

Court Oak Road (corner of Hampton Court Road), c1910. The distance from the High Street enabled a small shopping centre to develop here around the turn of the century.

Five

Along the High Street

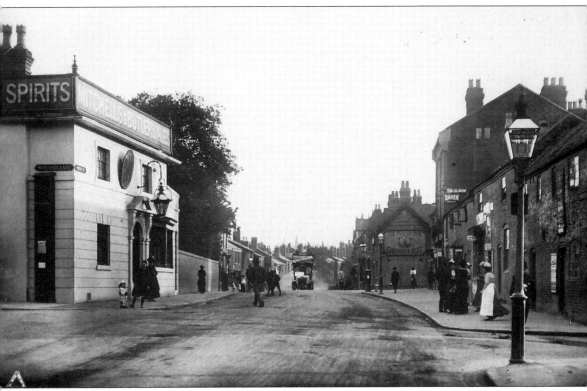

Metchley Lane corner, c1910. This was the view you saw when returning from Birmingham as you crossed over the boundary from Edgbaston into Harborne. The boundary came along Metchley Lane from the left and continued down Nursery Road to the right. The top end of the High Street, between Lordswood Road and The Junction pub was the original High Street of the village but as Harborne developed, shops and services spread down Heath Road which was later renamed as part of the High Street. The High Street was not only the main shopping centre, it was also the centre of community life. Around the High Strret were located the churches, the public houses, the board school and other institutions at a time when services and leisure were locally based.

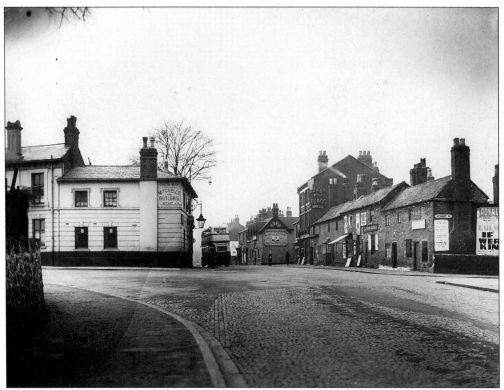

Metchley Lane corner, 14 September 1939. Little changed since the previous view thirty years earlier. The hoarding on the end wall of the cottages announced that Ronald Coleman was appearing at the Royalty Cinema.

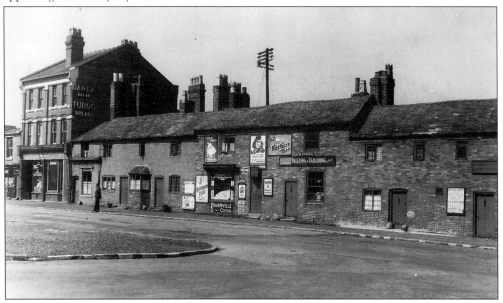

Nursery Road corner, c1948. The cottages are said to be former nailmakers cottages. Nailmaking was a staple cottage industry in Harborne for hundreds of years but had virtually died out towards the end of the nineteenth century.

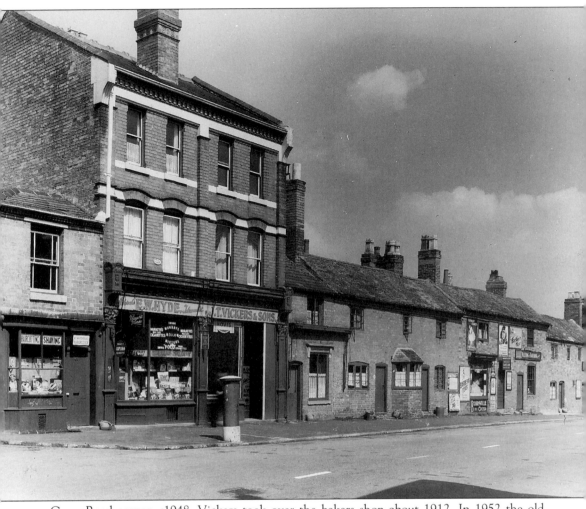

Grays Road corner, c1948. Vickers took over the bakers shop about 1912. In 1952 the old nailers' cottages were demolished and the "All Electric Bakery" (the first electrically operated in Birmingham, hence the name) built on the site. Vickers was taken over by Hughleys in the early 1960's. Building later used by the All Electric Garage for car preparation. Modern offices now occupy the site.

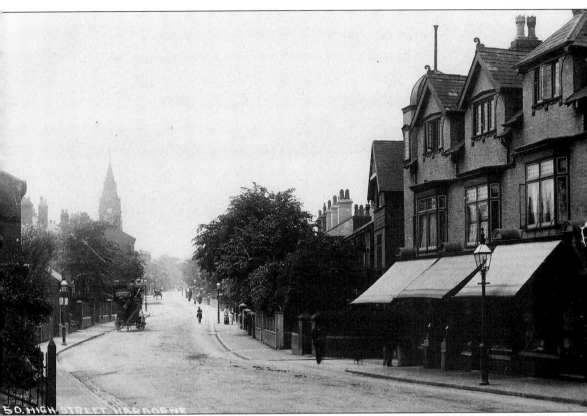

North Road corner, c1910. Redevelopment from the 1960's onward was to drastically change the appearance of this end of the High Street although the shops this side of North Road still remain.

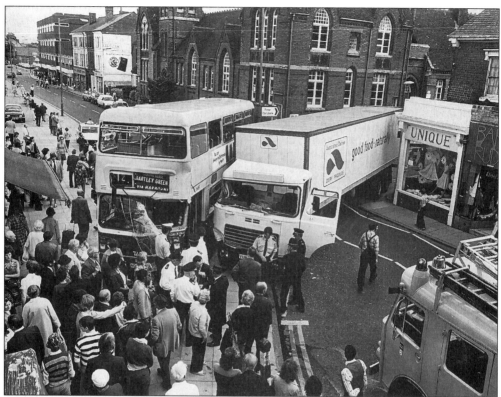

Accident at York Street corner, July 1978. It shows the High Street at a time of transition: the "Parade" had been built as had the new office block (top left). "Unique" and "Barnaby Rudge" were soon to be swept away to make way for "MacDonalds" and it's neighbours.

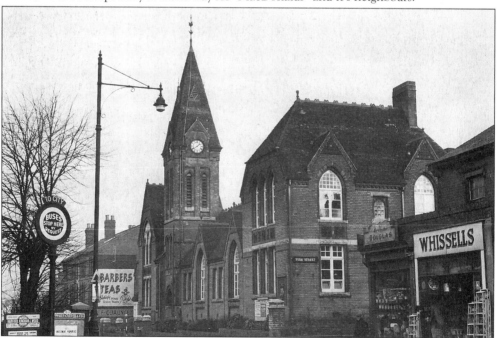

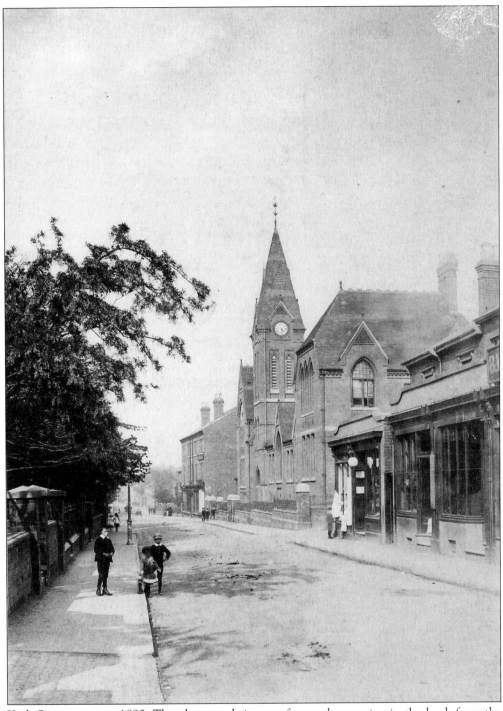

York Street corner, c1890. The photograph is one of several appearing in the book from the collection of the Rev. Edwards Roberts, Vicar of St Peters from 1858-1891.

Opposite: Clock Tower Centre, 1960. This was the first board school to be built by the Harborne School Board in 1881. Now the local adult education centre.

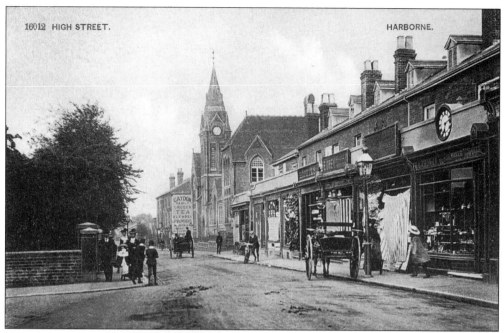

View from Station Road corner, *c*1900. The clock above the shop fronts indicates the premises of Willie Gardner, watch and clock maker.

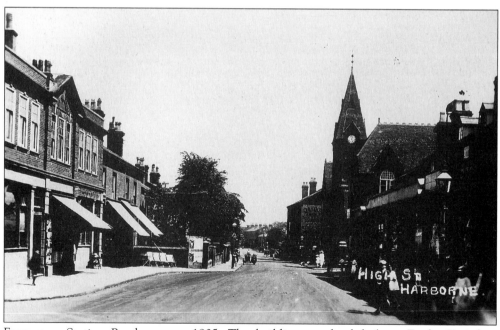

From near Station Road corner, *c*1905. The building on the left (now Fresha Fruits) is remembered by many local householders as Caves furniture store, with the post office next door and the Chad Cycle Co. beyond.

82

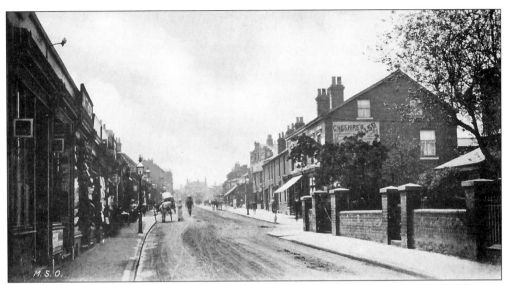

Looking up the High Street from near York Street corner, c1905. The prominent building on the corner of Station Road is "The Stores" public house.

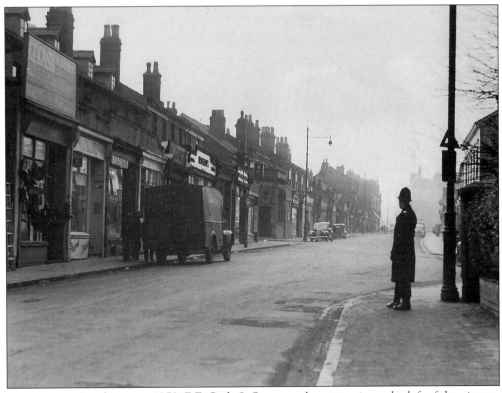

From Station Road corner c1952. E.F. Cash & Sons, surplus stores, is on the left of the picture. The old Midland Bank is on the corner of Bull Street next to Queens Cafe.

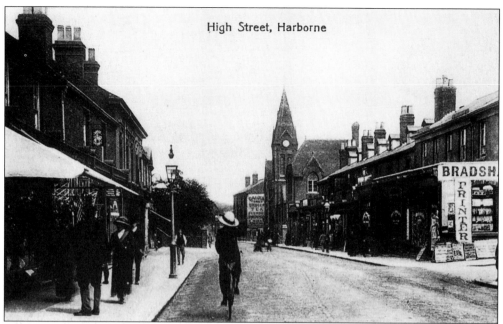

High Street, Harborne

Looking back from near Bull Street corner, *c*1912. Bradshaw was the village printer for everything from post cards to raffle tickets and published the Harborne Chronicle in the 1930's.

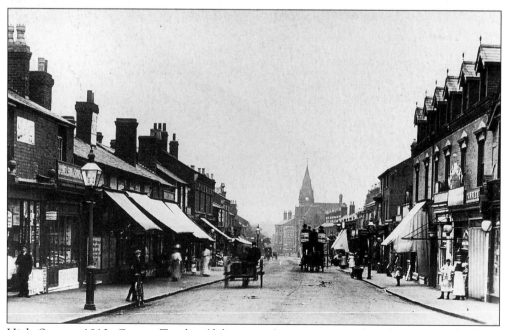

High Street, *c*1910. George Tansley (fishmongers) on extreme right of picture, with James Nelson (bakers) on the left between Frederick Holland (hairdresser) and Elizabeth Newey (stationers).

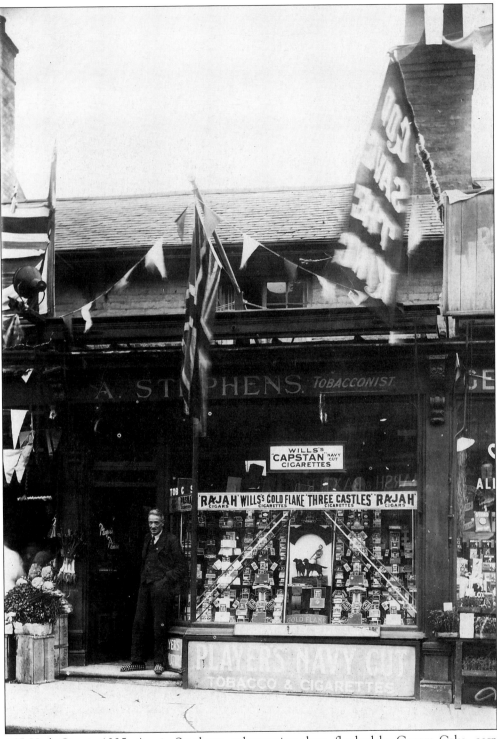

165 High Street, 1935. Annie Stephens, tobacconists shop, flanked by George Cake, corn dealer, and Leonard Martin, green grocer. Harborne was celebrating the Silver Jubilee of King George V at the time.

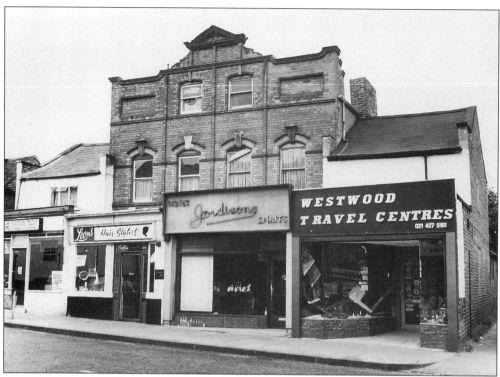

129-135 High Street, September 1972. Imagine the building without the shop fronts and you are looking at Harborne's original Weslyan Chapel. After the Methodists moved to South Street in 1868 the building was briefly used as a Roman Catholic Church (1870-1874) before being converted into shops.

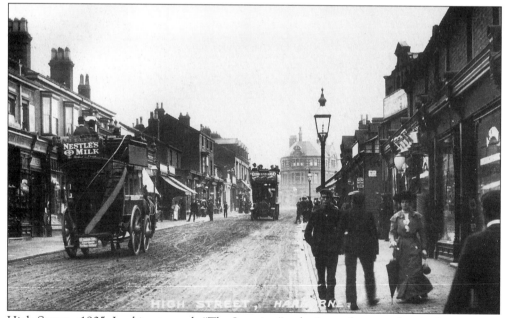

High Street, c1905. Looking towards "The Junction" pub. An early motor bus is about to pass the Harborne Horse Bus.

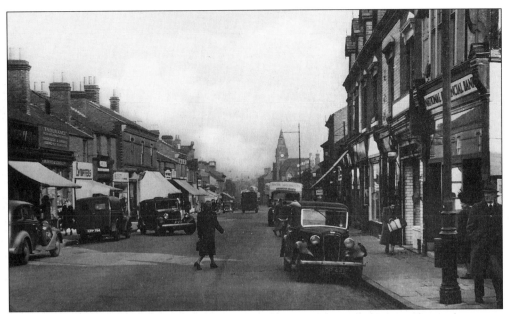

High Street, *c*1950. National Provincial Bank on extreme right next to MacFisheries (successor to Tansleys). Traffic congestion starting to become a problem on the High Street.

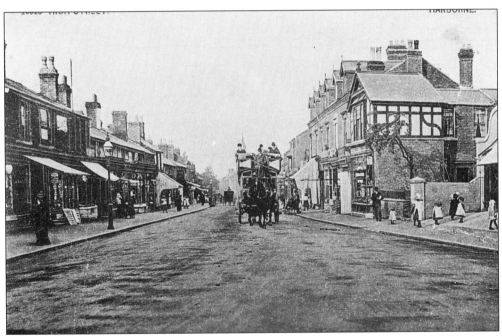

View from near "The Junction", *c*1900. Loaded horse bus about to pass the small half-timbered building which has altered little over the years. Boots Cash Chemist had their first shop here and Oak Terrace ran off the High Street alongside.

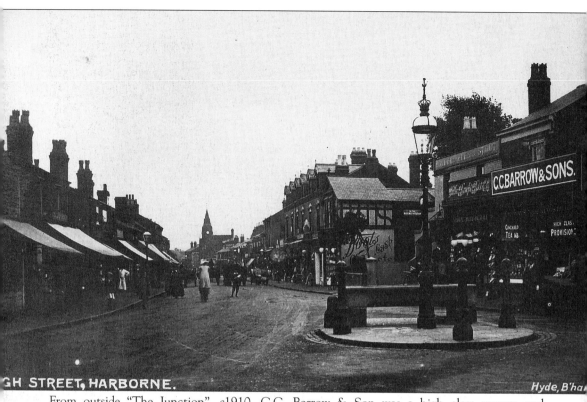

GH STREET, HARBORNE.

Hyde, B'ha

From outside "The Junction", c1910. C.C. Barrow & Son was a high class grocers and department store which lasted until the 1960's. Next door was the Public Benefit Boot Co. Woolworths later opened a shop on the site followed by Safeways in 1973. Safeways now occupy the whole of the site.

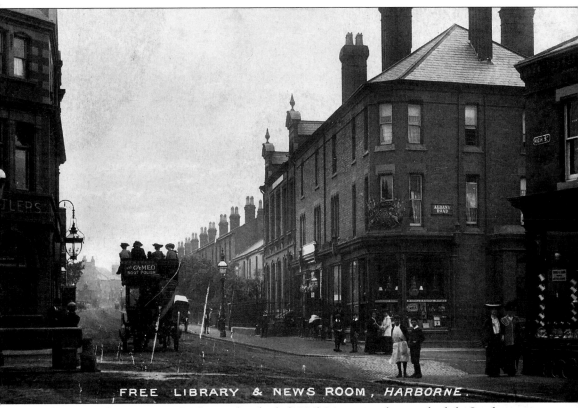

FREE LIBRARY & NEWS ROOM, HARBORNE.

Albany Road corner, c1905. The newly rebuilt (1904) Junction pub is on the left. On the near corner of Albany Road was John Collins, china dealer. This was replaced by Lloyds Bank in 1908.

Albany Road corner, 1890. There was a chemists shop on this corner for almost a hundred years. First Throngers, then Shaws for over seventy years and finally Harpers. Next door in Albany Road were the premises of the first Lloyds Bank in Harborne before moving to their present premises on the opposite corner.

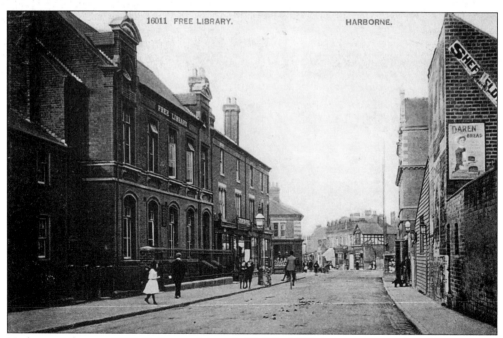

Harborne Library, c1905. Built as a Masonic Hall in 1870, it was converted to library use in 1892.

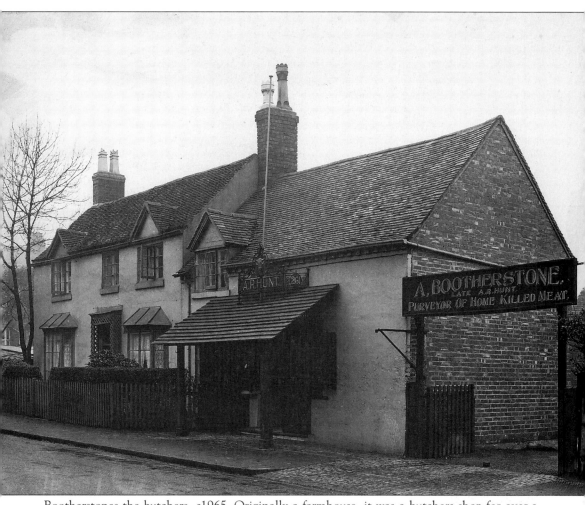

Bootherstones the butchers, c1965. Originally a farmhouse, it was a butchers shop for over a hundred years. Slaughtering was originally carried out on the premises. Sold up in 1965, site now occupied by petrol station.

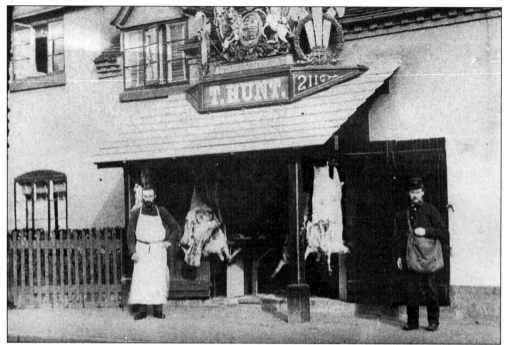

Hunts butchers shop, c1900. Griggs had the shop briefly in the early 1920's before being taken over by Bootherstones.

Station Road corner, 7 March 1935. The building on the right was originally built as the free school or charity school of Harborne. In 1837 the school moved to new premises near the church (now St Peters School) and the building had a variety uses over the years including a mews, a butchers shop before becoming the village police station. Now empty and boarded up.

Ravenhurst Road corner, c1905. Baptist Chapel on the left while the shop on the corner of Ravenhurst Road was for many years a high class grocers run by Harry Bashford (later taken over by John Favours). All the buildings shown have since been demolished.

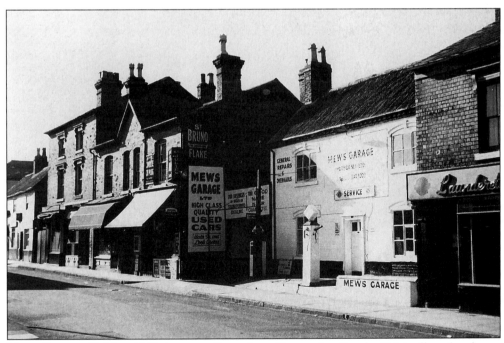

Mews Garage, 19 May 1963, between Ravenhurst/Serpentine Roads. Originally a farmhouse (Poyners Farm). The building to the left of the garage was built as the offices of the Harborne Local Board with a police station and cells at the rear.

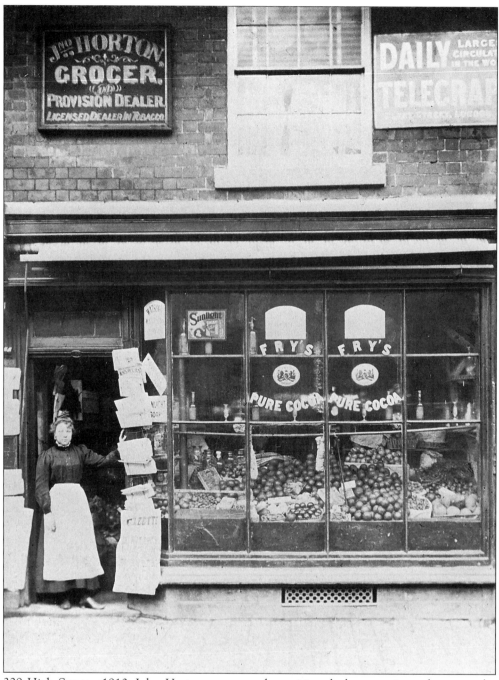

329 High Street, c1910. John Horton, grocer and provision dealer, was situated next to the Mews Garage. It later became an off license run by Miss Lilian Horton. In 1963 it was a laundrette.

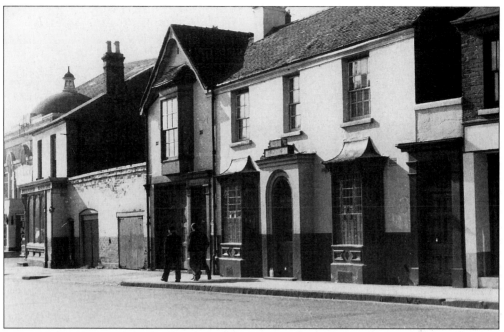

Vine Inn, 1965. Demolished in 1988, the new Vine Inn reopened the following year.

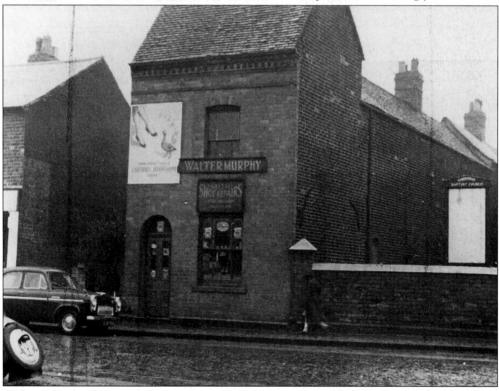

Walter Murphy, boot and shoe repairer, 1957. Later occupied by Kaltons the photographers. Now an insurance office. Alongside ran Vine Terrace (formerly Murphys Row), a row of nailmakers cottages.

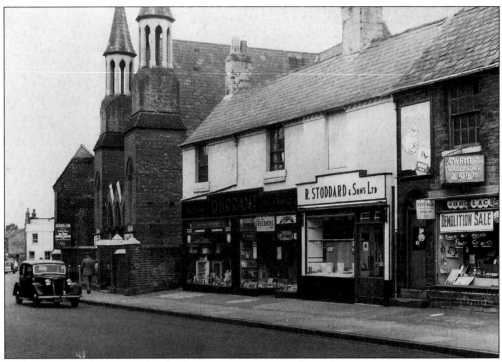

Baptist Chapel and shops, c1964. Techno House (built 1975) now occupies the site.

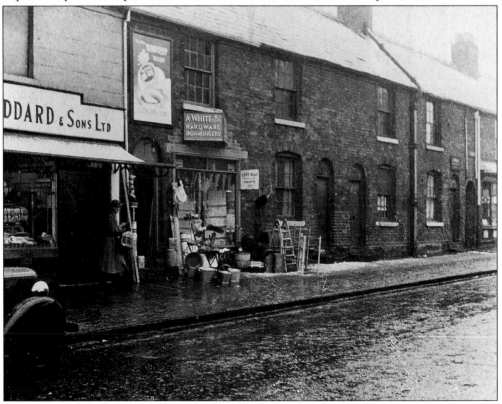

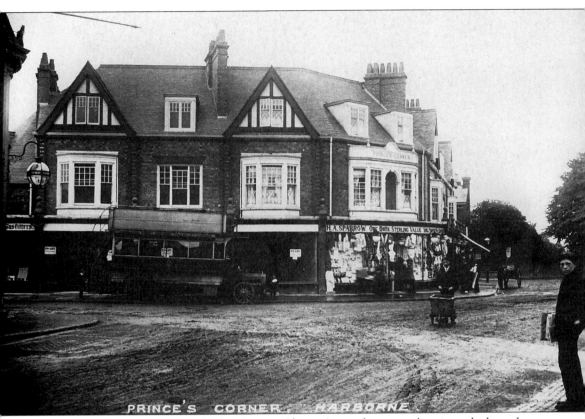

PRINCE'S CORNER, HARBORNE

Princes Corner, c1905. Named after Prince Abert. An early motor bus is parked at the Harborne terminus waiting to return along the High Street to Birmingham via Five Ways. This was the original centre of the old village and Prince's Comer occupies part of the old village green. This was where the stocks and the original village lock up were situated.

Opposite: A. White, decorators store, 1957. Established here in the 1930's, it closed in 1965 prior to the redevelopment of the whole site.

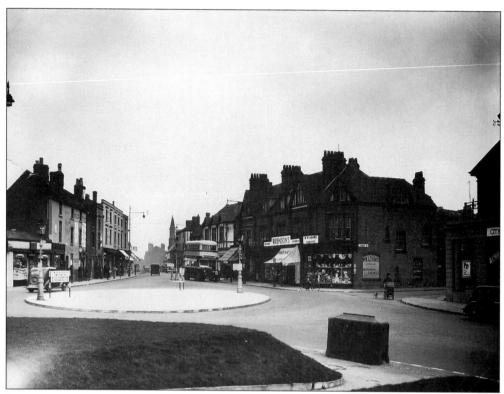

Princes Corner, 14 March 1939. By this time Wrensons had been established on the corner of Albert Road for over thirty years and was to remain for a further thirty.

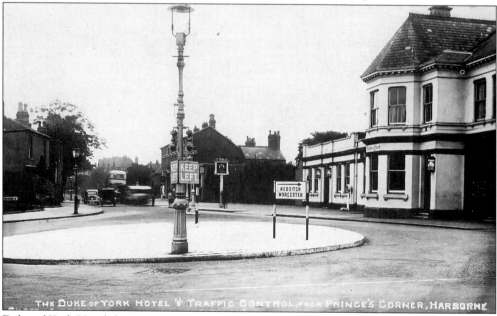

Duke of York Hotel, late 1930's. The newly installed traffic island was a sufficient novelty to justify the issue of a local postcard. Behind Frankly Terrace to the left was situated the former electricity power station.

Six
Social Life and Leisure

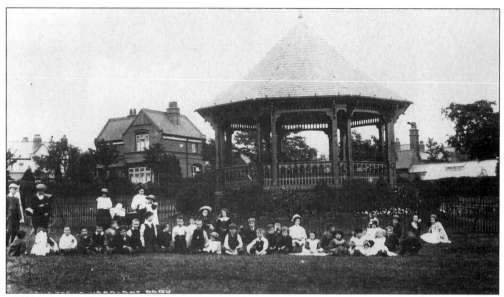

Queens Park, c1910. Bought by public subscription to celebrate the Diamond Jubilee of Queen Victoria's reign. The opening ceremony was performed by the Lord Mayor on 5 October 1898. Turks Lane was renamed Queens Park Road at the same time.

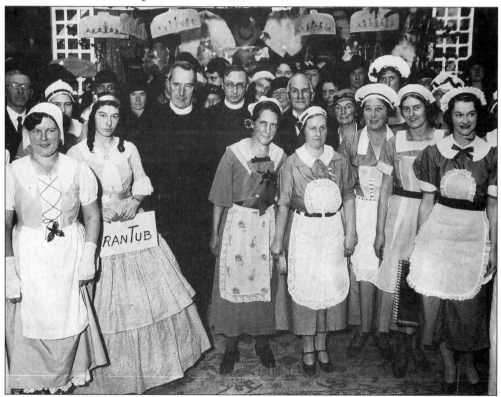

St Peters Yuletide Fair (held at Harborne Baths), 27 November 1935. Dr Inge, the famous Dean of St Pauls, with some of the helpers at the fair, which is said to be the only time he ever agreed to open a bazaar !

100

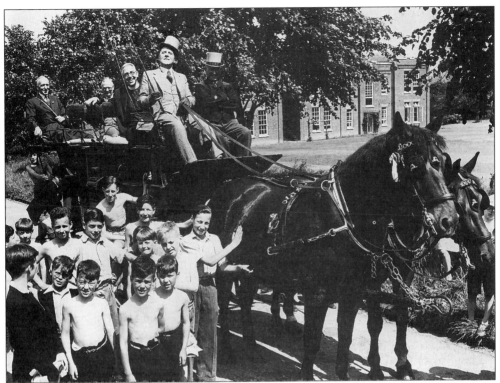

St Peters Summer Fete, 20 June 1950. Mr Gillie Potter, the famous comedian, poses with the Vicar of St Peters (Ven. S. Harvie Clark) at the Blue Coat School prior to driving to the vicarage field to open the fete.

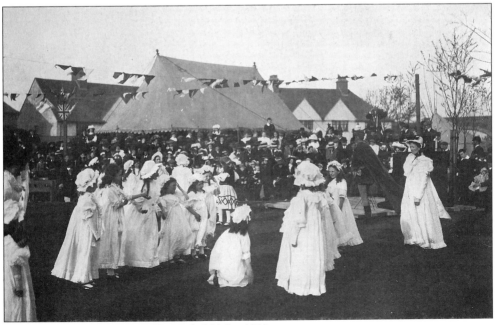

Harborne Tenants, May Day Festival, 14 May 1910.

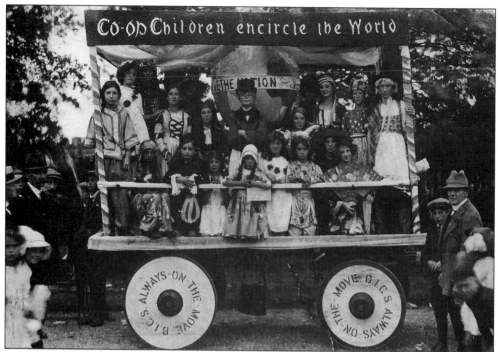

Co-operative Society float on the Moor Pool Estate, 1920's. Possibly in connection with the Harborne Charity Fete.

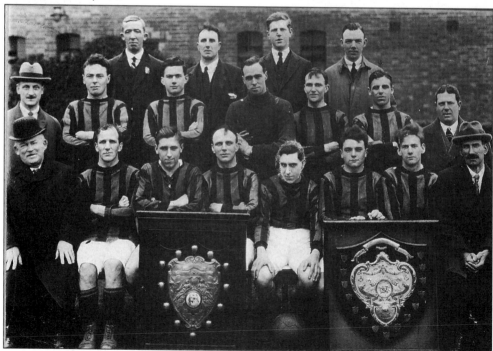

Harborne Lynwood Football Club, team of 1923/24. Founded in 1894 it was a formidable club between the wars and produced players for the Villa, the Blues as well as West Brom. It's pitches were in Lordswood Road.

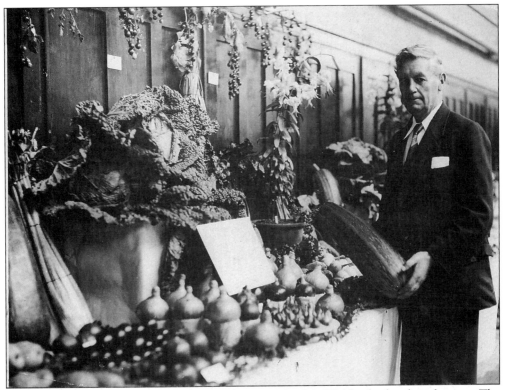

Harborne Horticultural Society, Annual Show, 1920's. Mr Webb, the head gardener at The Grove, was an honorary exhibitor and judge at the show for many years.

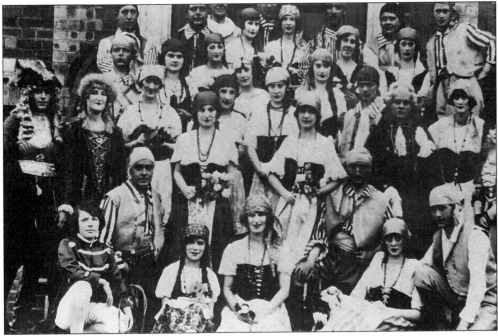

Harborne Operatic Society, c1926.

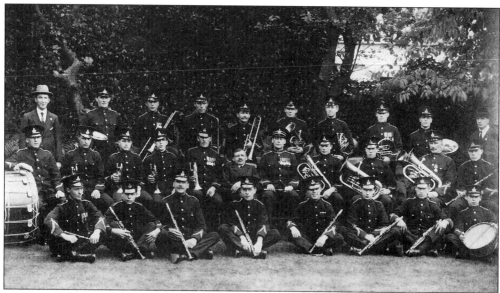

Harborne Military Band, 1924. Counc. Hooper (a well known solicitor who represented Harborne Ward from 1926-1937) was its president and is seated in the centre of the band.

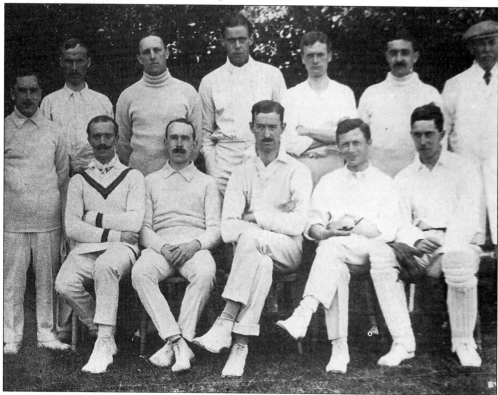

Harborne Cricket Club, touring team at Brighton, 1912. Founded in 1868 it moved to the grounds in Old Church road in 1874, a site shared with Harborne Hockey Club since 1903. During the Second World War the grounds were a barrage balloon station, the crew living in the pavillion.

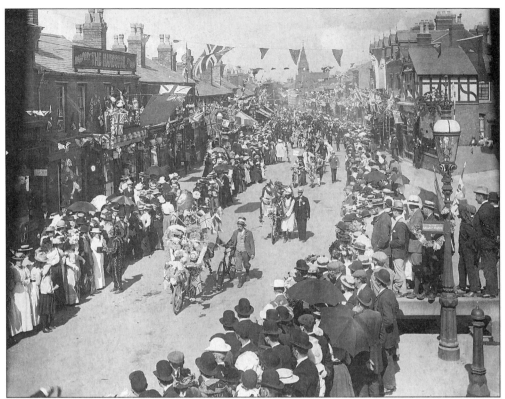

Coronation Celebrations, 22 June 1911. The "Grand Procession" on its way to Queens Park. The Grand Cycle Parade (prizes for best decorated cycle and charactor costume) is about to pass The Junction pub on the High Street.

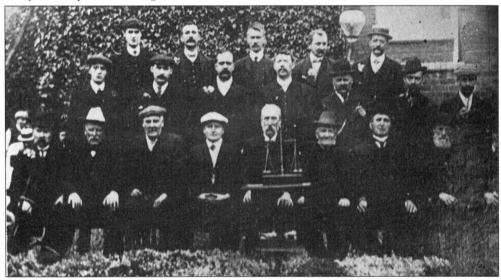

Harborne Gooseberry Growers Society, c1900. Founded in 1815 it was to develop into one of the premier clubs of the country. The annual shows were usually held at the Green Man pub. The society died out about 1923 but the official scales and measures are preserved in the Birmingham Museum & Art Gallery.

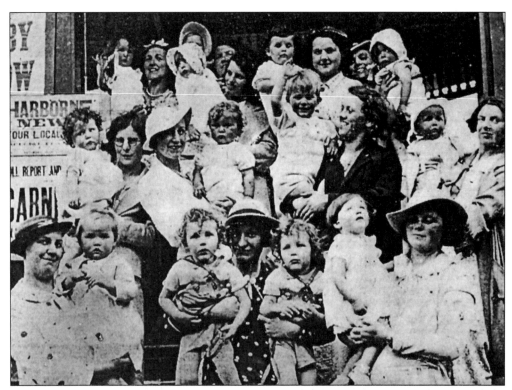

Harborne Charity Fete, 1937. Some of the entrants and their proud mums for the bonny baby competition. The annual charity fete, dating back to 1892, was one of the social events of the year. A procession up the High Street was followed by the usual fun and games in Queens Park.

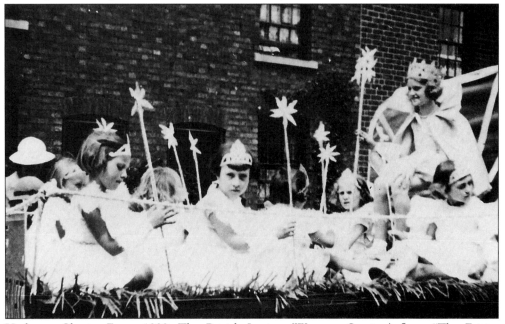

Harborne Charity Fete, c1939. The British Legion (Womens Section) float, "The Fairies Court" processing up the High Street on its way to Queens Park.

Seven

Institutions

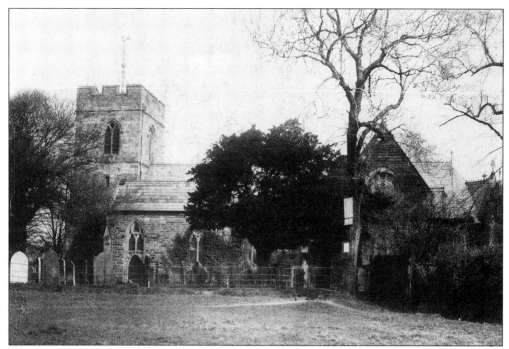

St Peters Church, 1885. This is the parish church of the ancient parish of Harborne, which included both Harborne and Smethwick. The tower is the only ancient part of the fabric and thought to date from the fifteenth century. The main body of the church was virtually rebuilt in 1867.

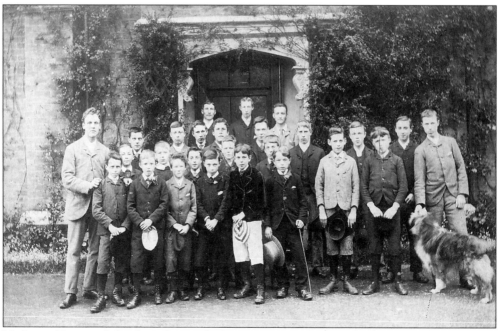

Harborne Vicarage School pupils outside the vicarage, c1888. Founded by Mrs Roberts in 1853, it moved to the school room at the vicarage in 1858 after her husband became vicar of St Peters, and continued there until her death in 1890.

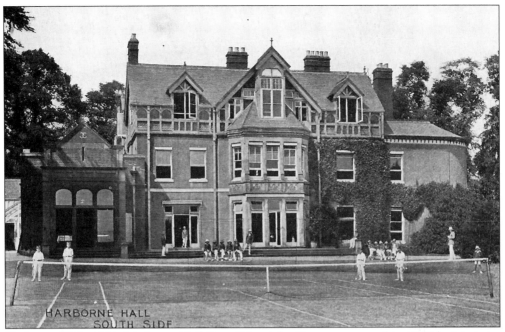

Harborne Hall, 1921. Harborne Hall Prep School for Boys was opened in 1919 by Montagu Lawson, previously of West House School (Edgbaston). Although the school built up a good reputation it only lasted until 1924.

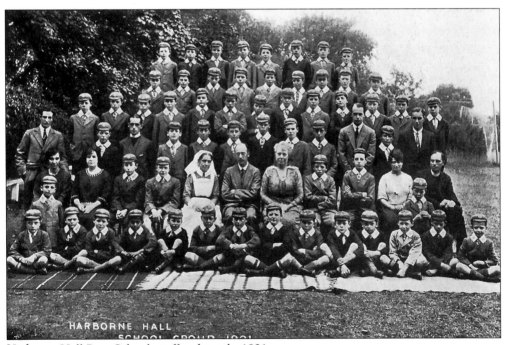

Harborne Hall Prep School, staff and pupils, 1921.

St Josephs Home, Queens Park Road, c1895. The Little Sisters of the Poor moved to Harborne in 1874 to provide accomodation and care for the elderly of modest means. A role they are still fullfilling.

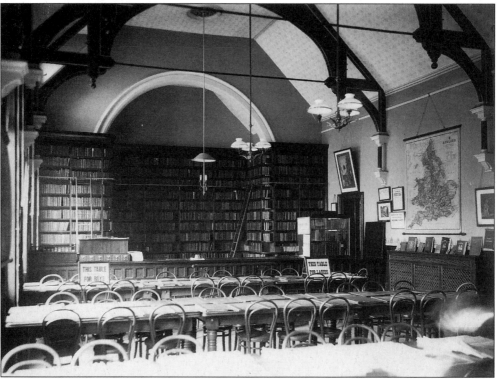

Harborne Library, 1910. The main library on the first floor (now the junior library). The library opened in the converted Masonic Hall in 1892 thus honouring one of the promises made to the ratepayers of Harborne, that a public library would be provided, if they voted in favour of annexation by Birmingham.

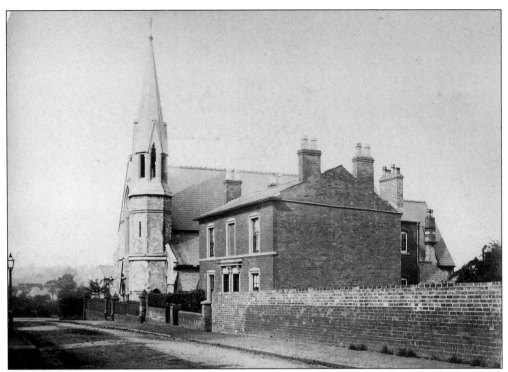

St Johns Church, St Johns Road, c1890. Consecrated in 1858, the church was destroyed by enemy action in 1941.

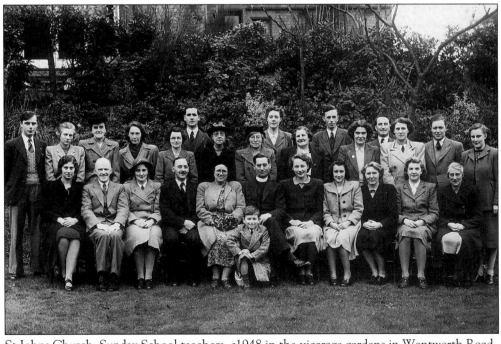

St Johns Church, Sunday School teachers, c1948 in the vicarage gardens in Wentworth Road.

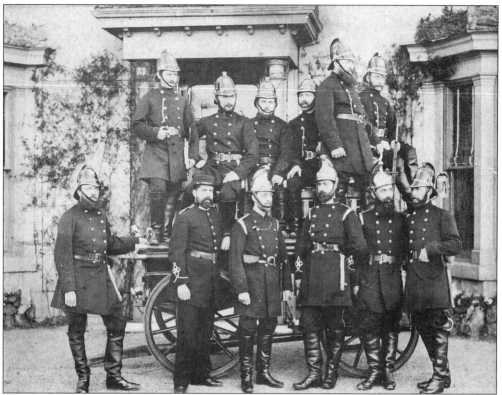

Harborne Volunteer Fire Brigade, c1888. The Volunteers were founded in 1879 by Charles Hart of Harborne Hall who was their first "Captain". Their headquarters were in Serpentine Road.

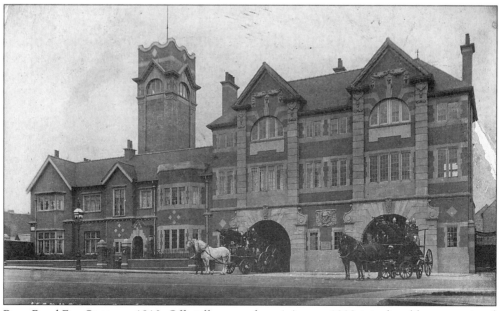

Rose Road Fire Station, c1910. Officially opened on 4 August 1908 it is the oldest operational station still in use by the West Midlands Fire Service.

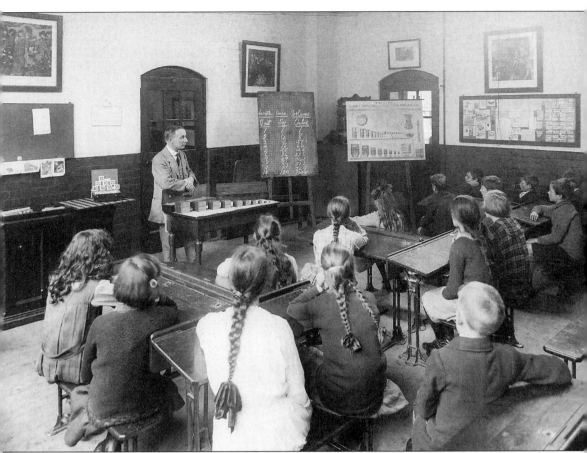

St Peters School, Mr "Billy" Hardwick the headmaster in class, early 1930's. Harborne Free School (or Charity School) was founded in the early eighteenth century. The original school was on the High Street but in 1837 it moved to its present site near the church. Between 1868 and 1936 the junior school only had two headteachers. The second was Mr William Hardwick (1907-1936) a man who contributed much to the life of the community as well as being a highly sucessful head. He is still remembered with respect.

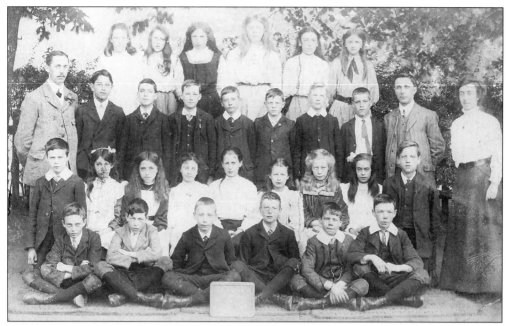

St Peters School, *c*1910. Mr Hardwick is second from right.

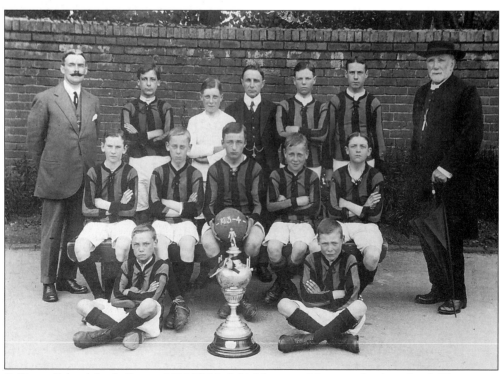

St Peters School football team 1913/1914. A highly sucessful season for the school. They swept all before them.

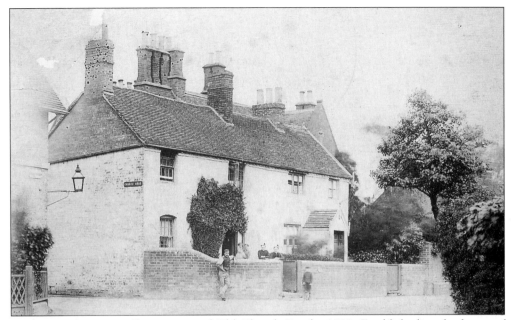

Harborne's first post office, corner of Old Church Road, c1900. Established at the home of Samuel Dugmore, the district registrar from 23 February 1844. Mr Dugmore was also the parish clerk.

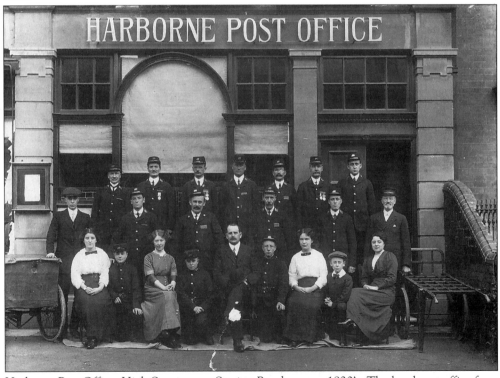

Harborne Post Office, High Street, near Station Road corner, 1920's. The local post office from 1915-1965. Note the "official" bicycle for the use of the Telegraph Messengers. Premises now occupied by Braggs the bakers.

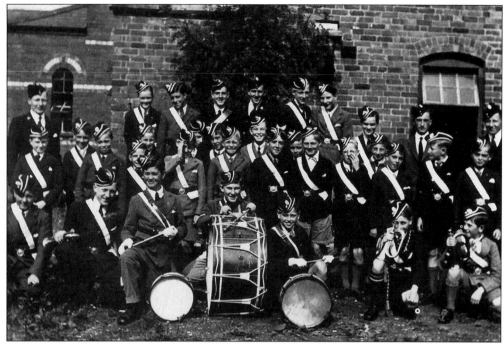

64th Birmingham Co. Boys Brigade, 1934. Group photograph at the rear of the Memorial Hall on the High Street with Captain David Taylor and Lieutenants Stan and Norman Cooper, and Fred Clement. The company is still flourishing.

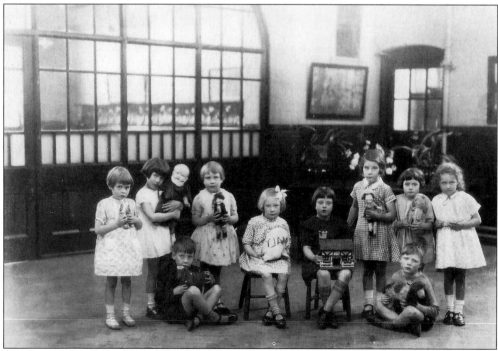

Station Road Infants School, c1930. The school opened in 1902 and was enlarged in 1912 when the infants department was transferred to it from the High Street school.

Eight
Miscellany

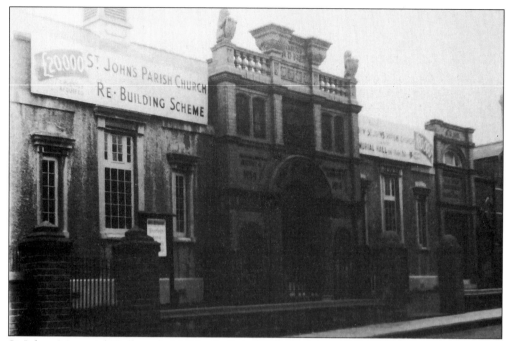

St Johns Memorial Hall, early 1950's. Built in 1862, St Johns Day School closed in 1917. In 1921 the building was given a new frontage as a memorial to local people who had died on active service. Demolished in the 1960's to make way for the new St Johns Church.

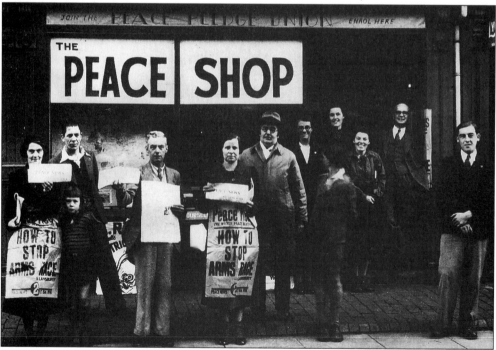

Peace Shop, High Street, late 1930's. The Peace Pledge Union came into being in 1934 and a Harborne group was founded shortly after. It taught a simple profound message of peace via Peace News which was sold on street corners every Friday evening.

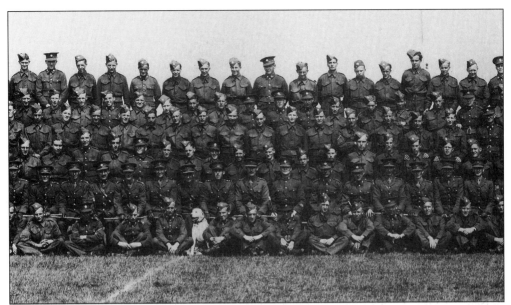

Part of 516 Ammunition Co. RASC, 1939. Mobilised from camp on Salisbury Plain in August 1939, the unit was based at the Court Oak Road Barracks. Composed of local lads.

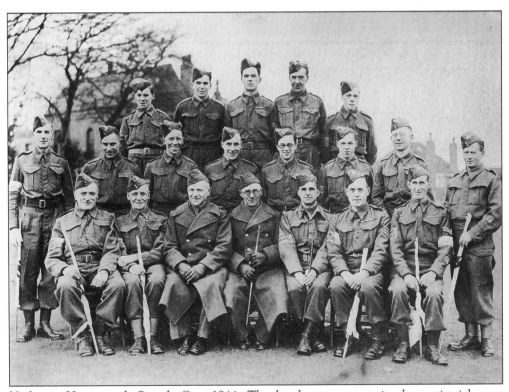

Harborne Homeguard, Signals Co. *c*1944. The headquarters were in the territorial army barracks in Court Oak Road. After the Homeguard was stood down in 1944, a final parade past the Birmingham Council House was held on 3 December 1944.

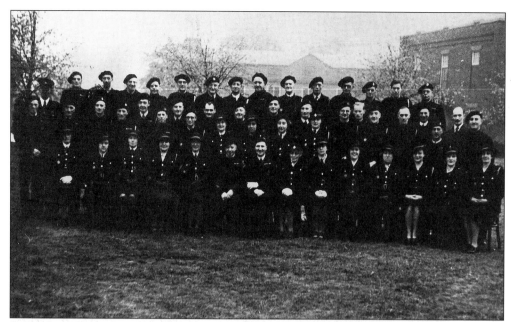

Air raid wardens, c1944. Local wardens in the grounds of the Blue Coat School shortly before being disbanded. Harborne was hit during several air raids and damage included destruction of St Johns Church and damage on the High Street.

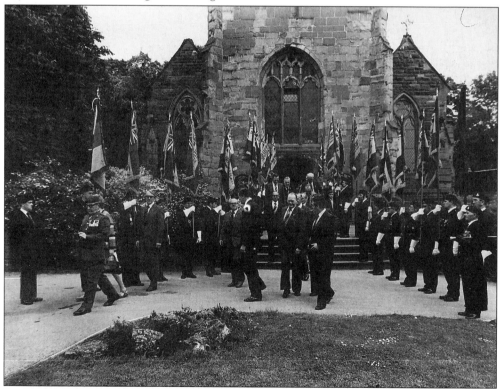

British Legion, church parade at St Peters Church, 17 June 1979. Held to celebrate fifty years at the Albany Road premises.

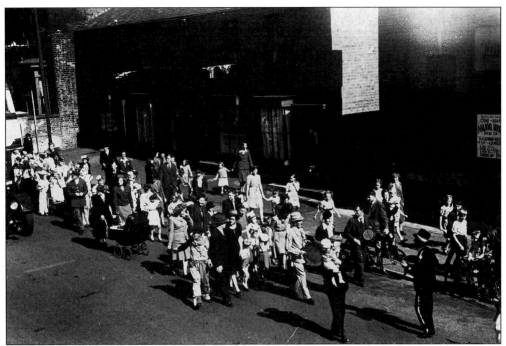

VE Day procession up the High Street, 1945.

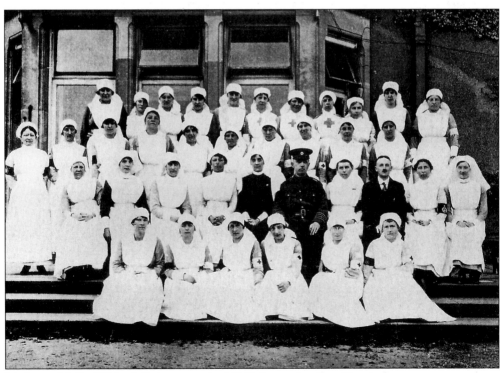

Harborne Hall, c1918, while in use as the VAD Avery Auxilary Hospital.

121

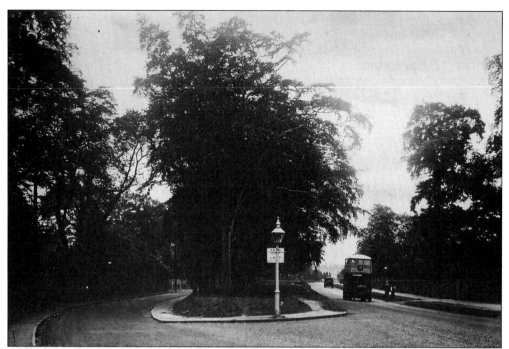

Harborne Park Road, c1930, from near Vivian Road corner, showing the new section of dual carriageway built as part of the Outer Circle improvements.

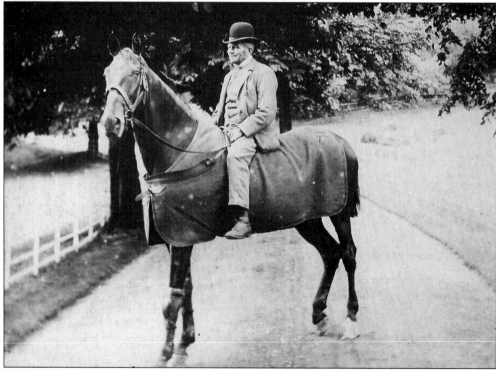

Jimmy Hicks, c1910. Mr Hicks was head coachman for the Kenrick family at The Grove for fifty years. He lived at the old lodge with his family and was well known in the village.

Bell Inn, c1910. One of Harborne's oldest and best known pubs. In 1897 it was nearly bought by St Peters Church with a view to closing it and adding the adjacent land to the churchyard. Not proceeded with !

Dick's muckcart by The Stumps, Harborne Park Road, c1900. What was carried in the cart I leave to the reader's imagination !

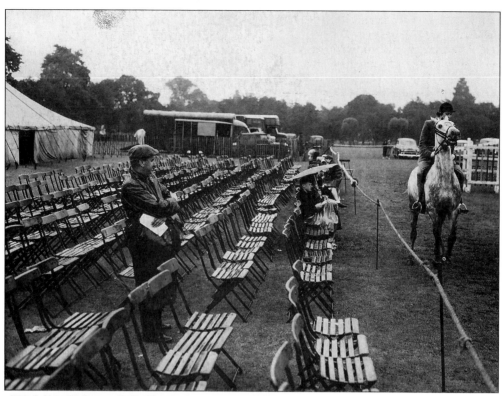

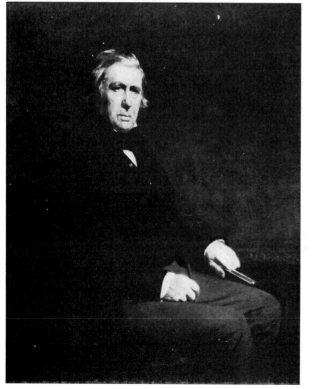

Harborne Horse Show, 12 July 1958. A brief attempt to resurrect the Harborne Horse Show. The leading light between the wars was Miss Bullows, whose riding school was in Barlows Road. The show was usually held in the field behind the stables.

David Cox, the water colourist, in 1855. David Cox was probably Harborne's most famour resident and the quality of his paintings earned him a national reputation. He lived at Greenfield House, Greenfield Road from 1841-1859.

William Burdett and family. Mr
Burdett was the verger at St Peters
and the parish clerk for fortyfive years
and passed away during divine service
on 5 March 1925 age 67. He was
noted for his resemblance to King
George V.

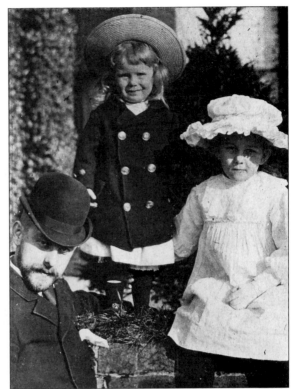

Ravenhurst Road, near High Street
corner, 1960's. Said to be the old Pass
House, where the travelling poor
could be put up overnight when the
workhouse was full. Demolished
1994.

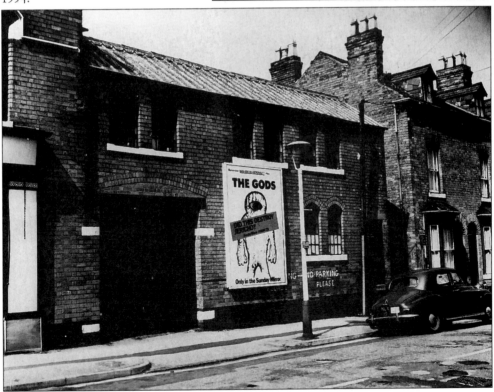

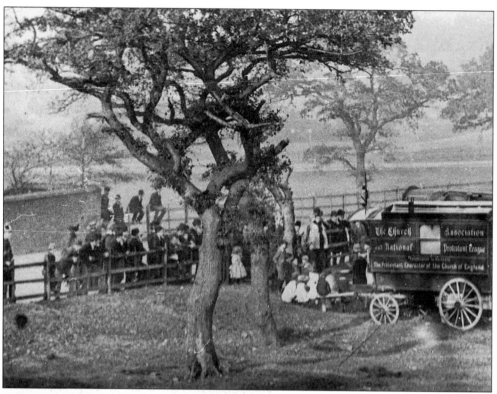

Regent Road, c1880. Travelling evangelist.

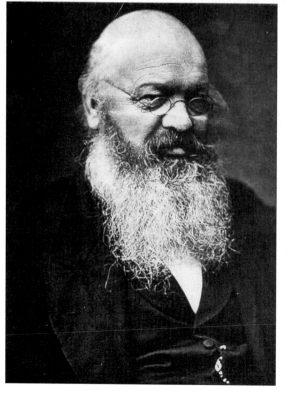

Edward Capern, the postman poet, c1870. Born in Tiverton 1819, Capern lived in Harborne, on the High Street, from 1868-1884. Many of the poems written during that period have a local theme. Capern Grove was named after him.

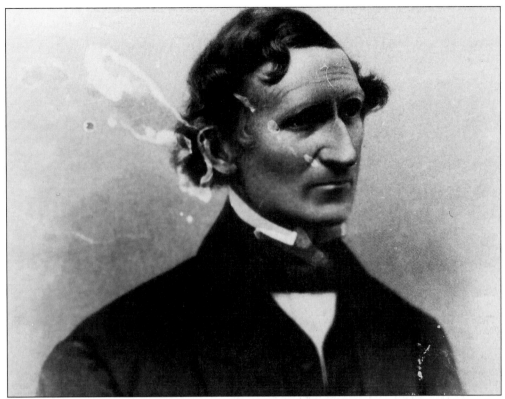

Elihu Burritt, American consul to Birmingham, 1865-1869. Appointed by Abraham Lincolm, his lasting fame rests on a book called "Walks in the Black Country and it's Green Borders" (1868). It was written during his term of office while living in Victoria Road.

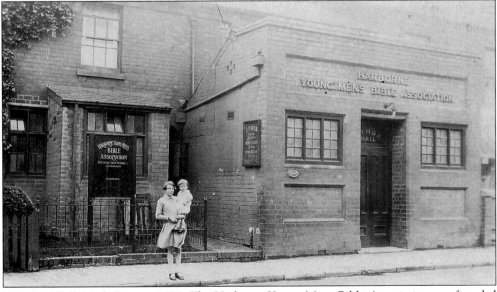

HYMBA Hall, High Street, c1930. The Harborne Young Mens Bible Association was founded in 1858 and was a very active influence in the life of the community. The hall was bombed in the Second World War.

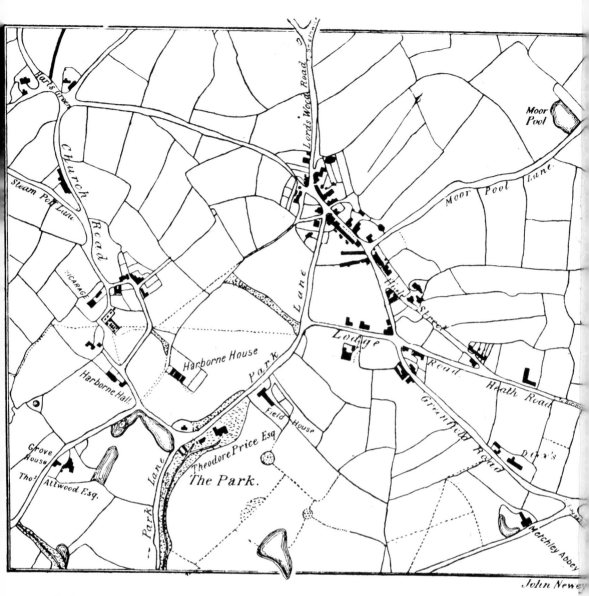

Harborne in 1834. Map which appeared in James Kenward's book called "Harborne and it's Surroundings" (2nd edition, 1885). A reminder of the way in which Harborne changed from the small country village of 1834 to a thriving Victorian suburb in such a short period of time. The map was drawn up by John Newey, the village builder.